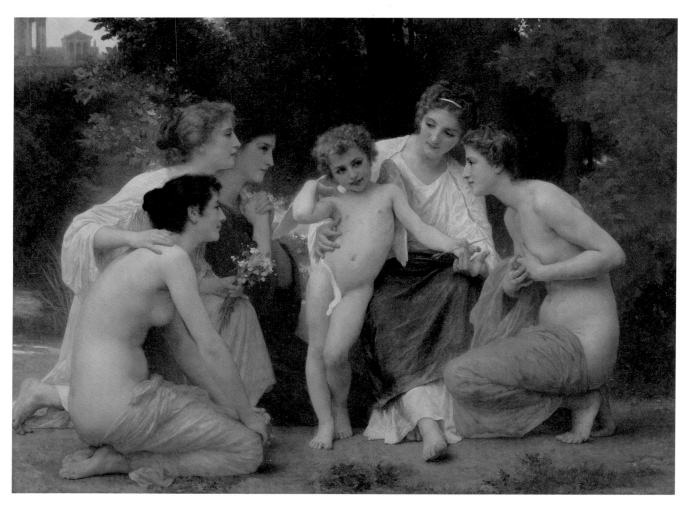

William Adolphe Bouguereau (1825 - 1905)
*Admiration (Admiration)*, 1897
oil on canvas, (58 in. x 78 in.)
San Antonio Museum of Art, San Antonio, Texas
Bequest of Mort D. Goldberg

# Five Hundred Years of French Art

Douglas K. S. Hyland

WITH ESSAYS BY

Richard R. Brettell

James Clifton

John Hutton

SAN ANTONIO MUSEUM OF ART

*Five Hundred Years of French Art* is published
by the San Antonio Museum of Art in conjunction with
the exhibition on view at the Museum from
April 8 through August 20, 1995.

Library of Congress
Catalogue Card Number: 95-67295

ISBN 1-883502-03-9

Photo Credits:
George Holmes: Figs. 76, 110, 113, 115
Stephen Tucker: Frontispiece, Figs. 7, 9, 10, 12, 46, 47, 50, 53, 67, 70, 72, 90, 102, 107
Paul Hester:  Fig. 6

Published in 1995 by
San Antonio Museum of Art
San Antonio, Texas

Printed by
Hearn Lithographing Company, Inc.
Houston, Texas

Distributed by
The University of Texas Press
Austin, Texas

Henri-Edmond Cross (1856 - 1910)
***Mediterranean Shore (Bords Méditerranéens)***, 1895
oil on canvas, signed lower left, (23-3/4 in. x 36-1/2 in.)
Private Collection, San Antonio, Texas
(Cover)

# Contents

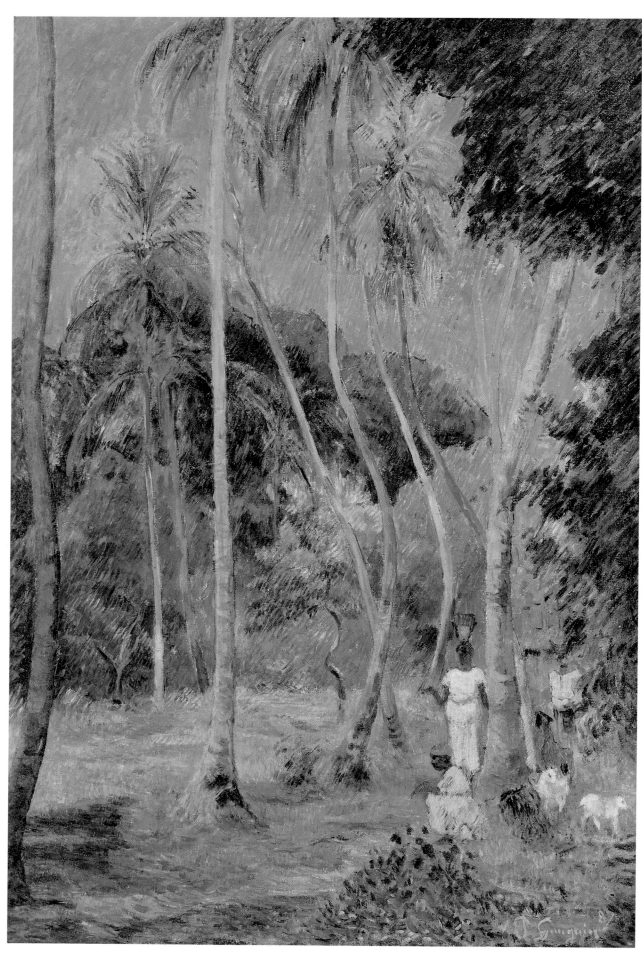

Fig. 1
Paul Gauguin (1848 - 1903)
**Path Behind the Palms, Martinique**
**(Le Chemin derrière des palmiers, Martinique),** 1887
oil on canvas, (35-1/8 in. x 23-3/4 in.)
Private Collection, Dallas, Texas

# *Acknowledgments*

Without the full support and cooperation of the lenders to this exhibition, it would have been impossible to proceed. I am most grateful to the Trustees of the Sarah Campbell Blaffer Foundation, Charles W. Hall, President, Jane Blaffer Owen, Cecil Blaffer von Fürstenberg, E. J. Hudson, Jr., and Gilbert M. Denman, Jr., for their unstinting support. Although the Foundation has been collecting French paintings of the sixteenth, seventeenth, and eighteenth centuries for many years, the paintings have never before been assembled as a group for public display. However, the Foundation's three major collections of English, Dutch, and Italian pictures have been appreciated by audiences throughout the country, in keeping with Sarah Campbell Blaffer's dictum that the collections be shared whenever possible. I am grateful to the Blaffer Foundation for unveiling the French collection in San Antonio, in conjunction with this major salute to French art.

Over the last several years, I have enjoyed becoming acquainted with Spencer Samuels, who has done so much to shape the Blaffer collections through the years. Dr. James Clifton, appointed Director last summer, immediately set forth his imprint on the activities of the Blaffer Foundation. He has begun to research and document works in the collection which have hitherto remained largely unexplored. As a scholar, he is well-qualified to elucidate aspects of the Blaffer collections, and in his public presentations he combines insight with wit, bringing to life long-deceased artists and vividly describing their work. His is the first of the three essays included in this catalogue. Marilyn Steinberger, Administrator, has done an excellent job responding to my numerous requests with efficiency and zeal. Colin Bailey, who is writing the definitive catalogue of the Blaffer's French paintings, has agreed to compose the explanatory labels accompanying the Blaffer paintings, thus contributing to the public's enjoyment and understanding of these works. In the past, the Blaffer Foundation has called upon a wide variety of different scholars, and I am grateful for their contributions to our understanding of the French paintings in the Foundation's collection.

When I first visited San Antonio four years ago, I was encouraged and pleased to learn that there were so many active collectors. French art especially has captured the imagination of a number of distinguished San Antonio art lovers. While several collections were inherited from parents or relatives who avidly visited French museums, dealers, and other collectors, many other collections have been formed over the last fifty years by their owners. Once I began my explorations, the size, quality, and variety of the French paintings owned by local collectors became increasingly impressive. Almost half the paintings and two-thirds of the sculptures and works on paper included in this exhibition are owned by San Antonians. Although a Puvis de Chavannes painting in the exhibition would have been included in all the major Puvis exhibitions in London, Paris, and elsewhere, and a Courbet would have been included in all the major monographs and other publications, to my knowledge, the vast majority of these locally owned paintings have never before been shown publicly in Texas. It is an unfortunate commentary on this last decade of the twentieth century that for reasons of security, the owners of these paintings shall remain unidentified, except by geographic location. At the same time, I would be remiss were I not to express my profound gratitude to the twelve anonymous lenders from San Antonio and elsewhere in Texas for their willingness to share with all of us these stunning collections which have been so lovingly assembled. In particular, I am grateful to one of Dallas' leading art patrons and collectors, whose enthusiasm and consent at the outset of this project provided encouragement at a crucial time in the evolution of the exhibition. By loaning three superb works, a Monet, a Cézanne, and a Braque sculpture, she helped fill important gaps in the exhibition. I also appreciate the

loan of two significant sculptures from the Patsy R. and Raymond D. Nasher Collection, Dallas, two contemporary paintings from David C. Goldsbury and Margaret M. Goldsbury, San Antonio, and a luxurious Daubigny through the generosity of Howard and Mary Ann Rogers, Kamakura, Japan.

Marion Koogler McNay, who founded the distinguished museum which bears her name, played a pivotal role in San Antonio as the first great collector of French paintings. Recently, the McNay celebrated its fortieth anniversary of distinguished service and achievement. I want to thank the Board of Trustees and staff of the McNay for once again demonstrating their cooperative spirit by agreeing to loan to this exhibition two important paintings and a group of prints from their excellent collection of works on paper. Dr. William Chiego, Lyle Williams, and Heather Lammers have earned my thanks. The Museum of Fine Arts, Houston, has acquired over the last twenty-five years a large number of extraordinary French paintings. Dr. Peter Marzio, Director, Dr. George T. M. Shackelford, Curator of European Painting, Dr. Alison de Lima Greene, Curator of Contemporary Art, and Charles J. Carroll, Registrar, have cooperated by loaning five paintings from the nineteenth and twentieth centuries to the exhibition. I remember with pleasure visiting Houston and spending the day with Dr. Shackelford and Dr. Greene surveying the many outstanding acquisitions that have been made in recent years. Jay Gates, Director, and Kimberly Bush, Registrar, of the Dallas Museum of Art, agreed to loan a fine Delaunay and Pissarro. They further assisted by coordinating the

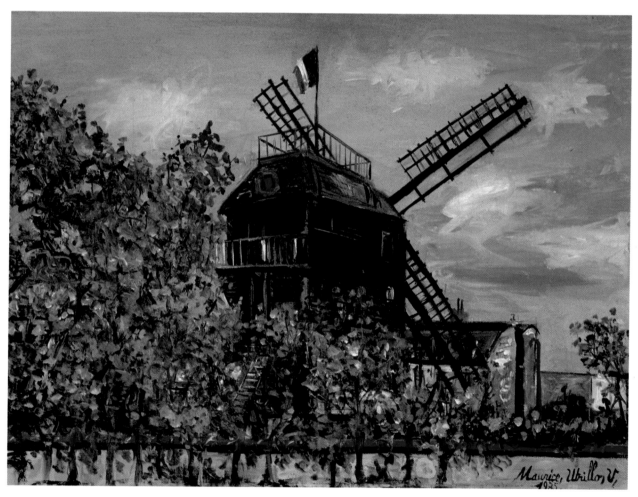

Fig. 2
Maurice Utrillo (1883 - 1955)
**The Moulin de La Galette at Montmartre**
**(Le Moulin de La Galette, Montmartre)**, 1935
oil on canvas, signed and dated lower right, (25-5/8 in. x 19-3/4 in.)
Mr. Walter F. Brown, Jr., San Antonio, Texas

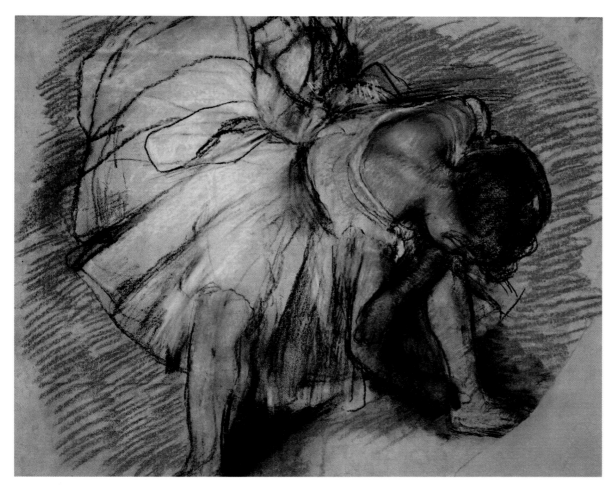

Fig. 3
Edgar Degas (1834 - 1917)
***Dancer Adjusting her Shoe (Danseuse adjustant son soulier),*** c. 1885
pastel on paper (19-7/16 in. x 23-3/4 in.)
The Dixon Gallery and Gardens, Memphis, Tennessee
Bequest of Mr. and Mrs. Hugo N. Dixon

loans of several private collectors in Dallas. Dr. Edmund P. Pillsbury, Joachim Pissarro, and Anne Adams at the Kimbell Art Museum are providing an incomparable Courbet and Hubert Robert from the distinguished Kimbell collection, known throughout the world for the quality of its French paintings. I am grateful to Mrs. Dominique de Menil, Paul Winkler, Director, and Ms. Susan Davidson, Associate Curator, The Menil Collection, for the loan of several outstanding twentieth-century works. Finally, Jesse Hite, Director, and Jonathan Bober, Curator of Prints and Drawings of the Archer M. Huntington Art Gallery at The University of Texas at Austin, agreed to provide a selection of early works on paper and a neoclassical portrait. Mr. Bober has set about establishing a representative collection of graphic works by the great French print makers, thus creating a major resource for the state of Texas.

I wish to thank the following for their assistance: Dr. Earl A. Powell III, Director, and Sally Freitag, Registrar, of the National Gallery of Art; Dr. E. John Bullard, Director, and Paul Tarver, Registrar, of the New Orleans Museum of Art; Dr. E. A. Carmean, Jr., Director, and Kip Peterson, Registrar, of the Memphis Brooks Museum of Art; Dr. Michael Milkovich, Director, Margarita G. Laughlin, Registrar, and Barbara C. Somerville, Administrative Assistant, of The Museum of Fine Arts, St. Petersburg; Katherine Lawrence, Acting Director, and Lisa Incardona, Registrar, of the Dixon Gallery and Gardens, Memphis, Tennessee; and Barbara Gibbs, Director, and Dr. John Wilson, Curator of Painting and Sculpture, of the Cincinnati

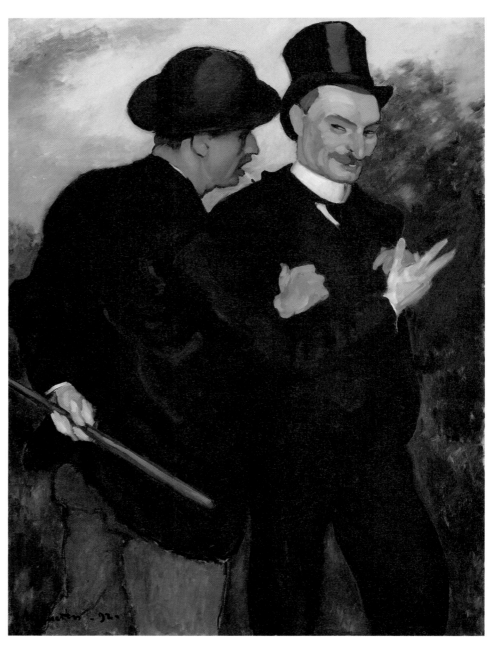

Fig. 4
Louis Anquetin (1861 - 1932)
**Two Men Talking (Deux hommes causant),** 1892
oil on canvas, signed lower left and dated, (51-1/4 in. x 38-3/4 in.)
Private Collection, San Antonio, Texas

Art Museum. While almost all of the works in this exhibition are drawn from Texas collections, it was necessary to seek important loans from other museums when certain works were unavailable in Texas.

Dr. Richard R. Brettell, former Director of the Dallas Museum of Art and now a distinguished independent scholar, contributed a stimulating essay on French landscape painting and also provided several significant leads, suggesting works of art that have strengthened the exhibition enormously. He also made certain observations on collecting in Texas which I have used in writing the introduction for this catalogue. Dr. Brettell has approached this project with enthusiasm and his usual brilliance. Dr. John Hutton, Chairman of the Art History Department at Trinity University, has addressed the Post-Impressionist artists of France in his essay, drawing on years of experience as a leading authority in his field. Both of these contributions, along with James Clifton's essay, provide excellent documentation and elucidation. Drs. Nanette Le Coat, Martha Ward, and Gary Kates also have shared their expertise with enthusiasm.

At the San Antonio Museum of Art, I wish to thank the following for their numerous contributions: Lila Cockrell, Andrea Loubier, Teresa Blaker, Jeff Johnson, Tim Foerster, Orlando Romero, Gabriela Truly, Rachel Lewandowski, Tracy Baker White, Molly Oswalt, Kathleen Nau, Nancy Hunicutt, Mobi Phillips, Susan Rios, Alex Holguin, Joanie Barr, Esther Lares, Jennifer Crone, Carmen Gutierrez, Mary Gray, and Abrahm Valdez. The staff has worked extremely hard and has been very diligent throughout the planning and mounting of the exhibition. Mary Meek deserves special commendation. I am pleased that the University of Texas Press will distribute this publication and thank Theresa May for her interest. Lois Rankin, once again, has been a resourceful editor. Janet Brown has been extremely cooperative. As always, my wife, Tita, was an enormous help throughout.

Funding has been provided by a wide spectrum of different sources, all of whom have a demonstrated commitment to increasing our appreciation for French art and culture. The Marcia and Otto Koehler Foundation–NationsBank Trustee, SBC Foundation, KENS-TV, the *San Antonio Express-News*, the Sarah Campbell Blaffer Foundation, Mr. and Mrs. Walter F. Brown, NationsBank, The Scaler Foundation, KLRN, The L. E. Bruni Family Charitable Trust, The Texas Committee on the Humanities, Southwest Airlines, and the City of San Antonio through the Department of Arts and Cultural Affairs have all contributed generously. Funds from the Everett and Helen Jones Endowment for Exhibitions and the Mary Kargl Endowment for Lectures have also been designated to support *Five Hundred Years of French Art*.

This catalogue and exhibition are dedicated to Faye L. Cowden, who has been such a guardian angel to the San Antonio Museum of Art.

D. K. S. H.

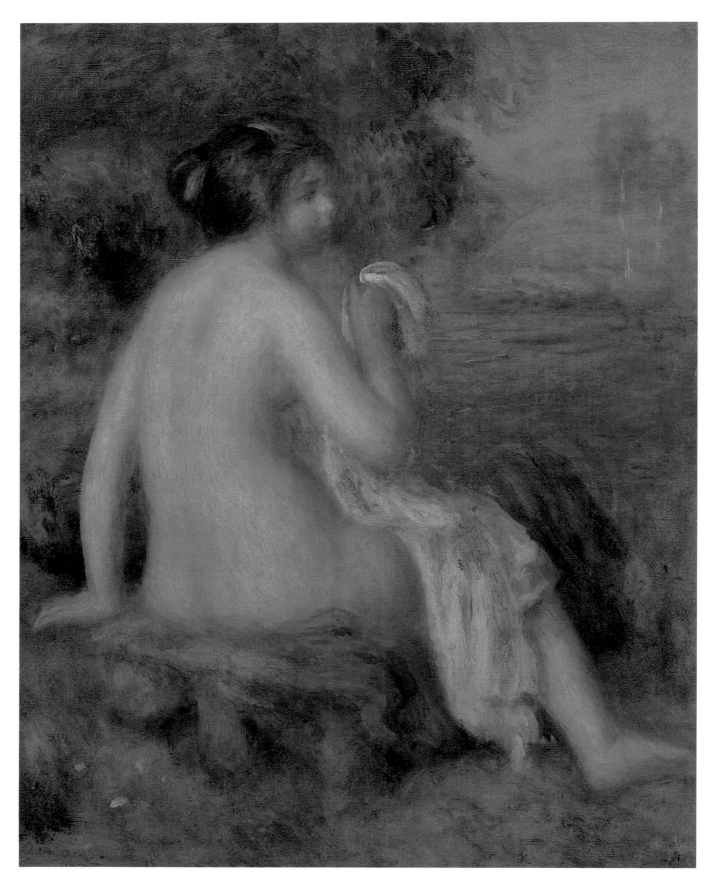

Fig. 5
Pierre Auguste Renoir (1841-1919)
**Woman Bathing (La Baigneuse),** 1896
oil on canvas, signed lower left *Renoir*, (16-1/8 in. x 12-5/8 in.)
Private Collection, San Antonio, Texas

# Introduction

**F**ive Hundred Years of French Art, as represented by the paintings, sculpture, drawings, and prints assembled in the exhibition, incorporates two very important components of the French mystique—the allure of the senses and the appeal of the intellect. France came to dominate painting in Europe shortly after the High Renaissance in Italy. The successive court-appointed painters established a standard of excellence unequaled in any other European court, and the founding of the French Academy under the Sun King, Louis XIV, set the stage for the emergence of an official French art establishment. Over the next two hundred years acceptance in its Salons insured the imprimatur necessary for artistic success in Europe, and hordes of Frenchmen and other nationals flocked to Paris as the mecca of the art world. Only in the late nineteenth century did the Impressionists and their followers triumph over the Salon system of the Academy, which codified the rules and regulations governing artists. In reaction against the Salons, a broad spectrum of exhibitions were organized by key international art dealers and a new cadre of art aficionados. Regardless of the changes, however, Paris remained the indisputable artistic center of the Western world, a preeminence it enjoyed until after the second World War.

For many Americans, their first direct encounter with France was during that war. Grim as those circumstances were, they could not completely extinguish the physical beauty of the French landscape, with its rolling hills and ancient villages, nor of Paris, with its glorious broad boulevards and stately architecture. Some returned from the war with special memories of such scenes, and they set about acquiring works of art that evoked these sensibilities. Many of these works by French masters, which symbolized the height of refinement and beauty, were passed on to the next generation of the family, or to museums.

Today, collectors are able to return often to France, thus constantly renewing their appreciation for French art and culture. Already, private collectors have given Texas museums hundreds of French paintings they collected themselves or inherited. Moreover, the Brown, Cox, Denman, Levy, McDermott Menil and Nasher Collections, to name only a few, are among the best private holdings of French art in the world. By giving or sharing their artworks with museums, these collectors have enriched all of our lives immeasurably. Sarah Campbell Blaffer, an avid collector during her lifetime, by creating in her will the foundation which bears her name, epitomizes this noble effort. By loaning and giving notable French paintings throughout the state, the Blaffer Foundation has influenced millions of people. The consequent effect of this effort and countless others on the status of Texas museums has been just short of phenomenal.

Two of the state's art museums were founded at the turn of the century, and initially operated on a modest scale. The Museum of Fine Arts, Houston, opened its doors in 1900; the Dallas Museum of Art in 1903. The San Antonio Museum Association, the parent of the San Antonio Museum of Art, traces its origins to 1923. These museums presented small-scale changing exhibitions of French art and provided access to permanent collections that varied in size and quality. These three distinguished museums and those that followed, the Marion Koogler McNay Museum (1954), the Archer M. Huntington Art Gallery at The University of Texas at Austin (1963), the Kimbell Art Museum (1972), and the Menil Collection (1980), did not begin to flourish until many years after the war, largely as a result of the oil boom that ensured the state's economic prosperity. In the 1970s, wealthy private collectors and patrons fueled the spectacular growth of these art institutions while simultaneously amassing enormous private collections. The economic recession of the late 1980s and early 1990s had a disastrous effect on the state's art collectors and museums; however, today,

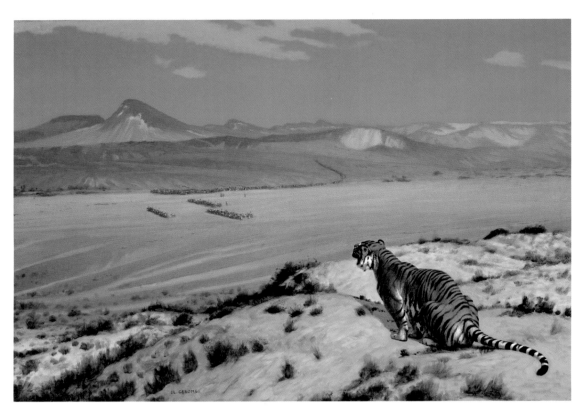

Fig. 6
Jean-Leon Gérôme (1824 - 1904),
*Tiger on the Watch (Le Tigre en garde)*, c. 1888
oil on canvas, (25 in. x 35-5/8 in.)
The Museum of Fine Arts, Houston
Gift of the Houston Art League, George M. Dickson Bequest

Fig. 7
Narcisse Virgile Diaz de la Peña (1807 - 1876)
*The Gypsy Princesses (Les Princesses gitanes)*, c. 1865-70
oil on panel, (31-1/2 in. x 23-3/4 in.)
Private Collection, San Antonio, Texas

ambitious new building projects are being planned and endowment expansions are underway. In Dallas, the new Museum of the Americas is a tribute to that city's support of the arts despite adverse economic conditions.

The donation of the Reves Collection to the Dallas Museum of Art, the constant refinement and expansion of the collection of the Kimbell Museum in Fort Worth, and the ever-expanding John A. and Audrey Jones Beck Collection at The Museum of Fine Arts, Houston, are but three examples documenting a trend towards increasing interest in French art. The Blaffer Foundation's collection has been assembled in the last ten years, a remarkable feat in view of the sharply escalating cost of such paintings. The great Texas museums are richer in the cultural patrimony of France than ever before. No major retrospective of a French artist would be complete without significant Texas loans. The galleries and museums of Texas are particularly strong in works by Monet, Renoir,

Fig. 8
Henri Matisse (1869 - 1954)
**The Red Blouse (La Blouse rouge)**, 1936
oil on canvas, (18-3/8 in. x 13-1/8 in.)
McNay Art Museum, San Antonio, Texas
Bequest of Marion Koogler McNay

Fig. 9
Pierre Auguste Renoir (1841-1919)
**Male Figure (Figure d' homme)**, c. 1918
bronze relief, ed. 5/20, signed lower right *Renoir*, (24 in. x 17-3/8 in.)
Private Collection, San Antonio, Texas

Fig. 10
Pierre Auguste Renoir (1841-1919)
**Female Figure (Figure de femme)**, c. 1918
bronze relief, ed. 19/20, signed lower left *Renoir*, (24 3/8 in. x 17.25 in.)
Private Collection, San Antonio, Texas

Fig. 11
Berthe Morisot (1841-1895)
**Skaters (Les Patineurs)**, c. 1874
pastel on paper, (17-1/4 in. x 23-1/4 in.)
Private Collection, San Antonio, Texas

Sisley, Pissarro, Cézanne, Gauguin, Caillebotte, Redon, Signac, Vuillard, Bonnard, Braque, Toulouse-Lautrec, Derain, and Matisse, thus demonstrating a marked preference for the works of the great nineteenth century Impressionists.

Over the last decade, French exhibitions and catalogues curated and written by Dr. Richard R. Brettell, Dr. Edmund P. Pillsbury, Dr. George T. M. Shackelford, and others have exerted an international influence. Just as the number of museums has grown, many ambitious expansion plans have dramatically increased the space available for changing exhibitions and the permanent collections of French art. The recent Pissarro exhibition at the Dallas Museum, the Barnes Collection at the Kimbell, and the Degas landscape retrospective at The Museum of Fine Arts,

Fig. 12
Odilon Redon (1840 - 1916)
**Still Life-Vase and Flowers
(Nature Morte-vase et fleurs)**, n.d.
pastel, signed lower right *Odilon Redon*
(15 in. x 12 in.)
Private Collection, San Antonio, Texas

Houston, were all enormously successful, drawing record crowds and further expanding the popular taste for French art. During the Barnes Exhibition, the Kimbell announced the purchase of a spectacular Matisse; this coup was followed recently by an equally fine Corot. Announcements from the Dallas and Houston Museums chronicle their major acquisitions, and only recently, the McNay celebrated its fortieth anniversary by displaying its recent donations and purchases.

The state's museums undoubtedly will expand their holdings in years to come through bequests, gifts, and purchases. The French collections in Austin, Dallas, Fort Worth, Houston, and San Antonio together form an impressive cultural patrimony for Texans, all the more remarkable for having been assembled in little more than a few generations. Scattered as they are throughout the state, it is fortuitous that so many of the state's French treasures should be assembled in this exhibition in San Antonio.

D. K. S. H.

Fig. 13
Robert Delaunay (1885-1941)
**The Eiffel Tower (La Tour Eiffel),** 1924
oil on canvas, (72-1/2 in. x 68-1/2 in.)
Dallas Museum of Art
Gift of the Meadows Foundation, Inc.

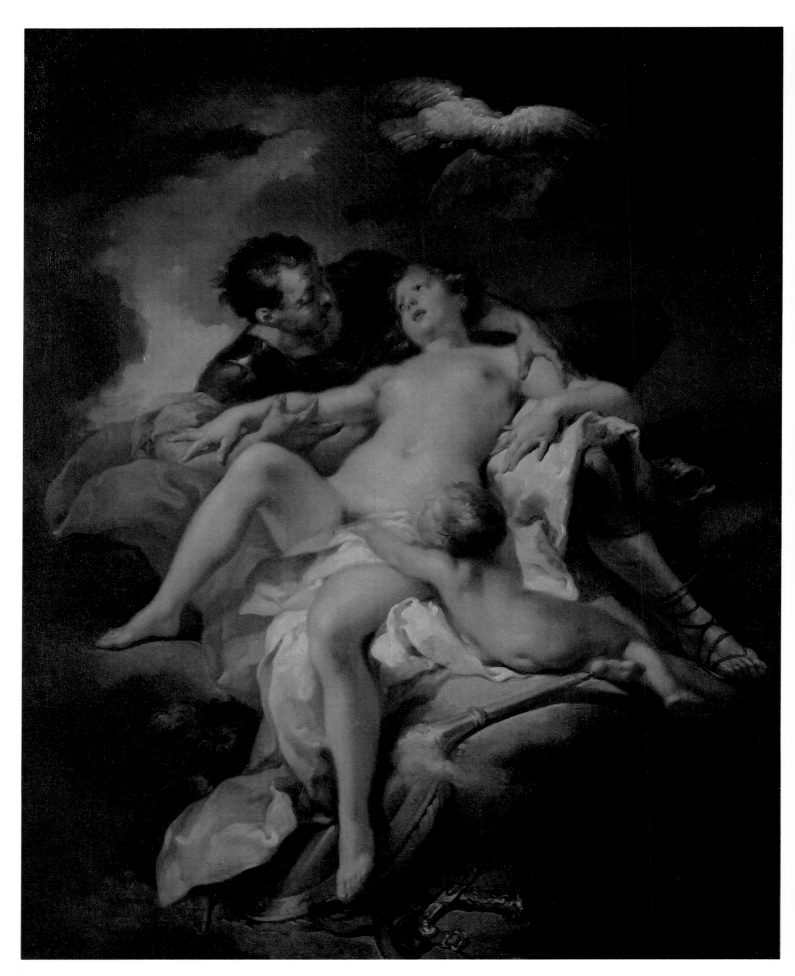

Fig. 14
Carle Van Loo (1705 - 1765)
**Mars and Venus, *(Mars et Venus)*** c. 1730, oil on canvas, (32 in. x 26 in.)
The Sarah Campbell Blaffer Foundation, Houston, Texas

# French Painting
# of the Ancien Régime:

THE COLLECTION OF THE SARAH CAMPBELL BLAFFER FOUNDATION, HOUSTON, TEXAS

**JAMES CLIFTON**

It was in the Louvre during a wedding trip to Paris in 1909 that Sarah Campbell Blaffer—born in Waxahachie, Texas, and raised in Lampasas and Houston—first experienced the profound, life-affecting thrill that turned her into an avid and knowledgeable art collector. Her tastes were eclectic, although she had a preference for European paintings. Many of these she gave to The Museum of Fine Arts, Houston, including works by Giovanni di Paolo, Mabuse (Jan Gossaert), Hals, Canaletto, Boucher, Renoir, Cézanne, and Degas. Following her death in 1975, the trustees of the foundation she established decided to acquire fine examples of European painting that would be made available to the people of Texas. Traveling in coherent collections—such as Italian paintings from the fourteenth to the eighteenth century, Netherlandish paintings of the sixteenth and seventeenth centuries, and English paintings of the sixteenth to eighteenth centuries—the works have been exhibited in many museums and galleries in Texas and beyond. Most of the French paintings have been collected since 1987 and are exhibited together here for the first time.

The purpose of all the Blaffer Foundation's collections, in keeping with Mrs. Blaffer's own interests, has been didactic; thus a guiding principle behind the formation of the collections has been to make them as fully representative of the painting of a given place and period as possible. The variety of types and styles of paintings in seventeenth-and eighteenth-century France, and the reflection of that variety in the Blaffer Foundation collection of French paintings, should be manifest in the essay that follows, which is intended to put these works in their historical perspective. Of course, not all the works can be mentioned, much less illustrated.

## FRENCH PAINTING—BETWEEN ITALY AND FLANDERS

Nicolas Poussin, the greatest French painter of the seventeenth century, wrote from Paris in 1642: "Alas, here we are too far from the sun to discover anything of delectation. Only hideous things pass before my eyes."[1] Poussin's sun was, of course, Rome, whose light of classical and Renaissance culture shone as a beacon to the rest of Europe. There he had spent virtually all of his career working in self-imposed exile (his comments about the aesthetic dreariness of Paris were made during a brief period of forced repatriation). For well over a century, Italy—especially Florence and Rome—had exercised a cultural hegemony in the visual arts, propagated by the Italians themselves but accepted enthusiastically by foreigners such as Poussin. In 1538 Michelangelo is reported to have said that "since in Italy...one makes works of painting more masterfully and with more respect than anywhere else, we call good painting Italian...[Painting] has maintained itself since antiquity in our Italy more than in any other country of the world, and I think that it will maintain itself there until the end." Since Charles VIII's invasion of Italy in 1494, the French monarchy had striven to make the glories of Italian culture its own, and French artists through the eigh-

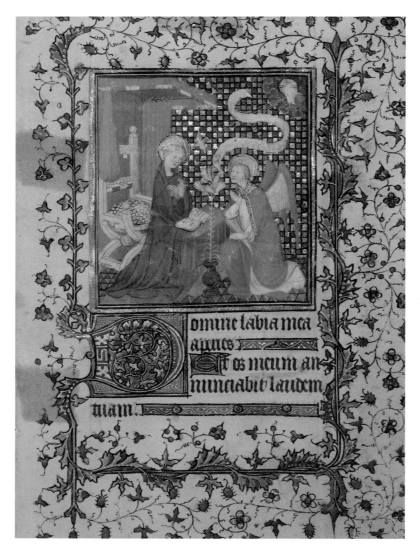

Fig. 15
Workshop of the Boucicaut Master, French School, (c. 1410)
**Annunciation (L'Annonciation),** 15th century
tempera and gilding on vellum (6-5/8 in. x 4-7/8 in.)
The Sarah Campbell Blaffer Foundation, Houston, Texas

teenth century consistently looked to Italy for artistic guidance, facilitated after 1666 by the establishment of the French academy in Rome—a sister institution to the recently founded *Académie Royale de Peinture et de Sculpture* in Paris. Many seventeenth- and eighteenth-century French artists, especially history painters, spent years studying and working in Rome.

André Félibien, the official historiographer of the Academy in Paris in the later seventeenth century, in his *L'Idée du peintre parfait* of 1707, follows traditional critical models and reduces the different "national tastes" *(Gôuts de Nation)* to six: Roman, Venetian, Lombard, German, Flemish, and French. He equates German taste with the Goût Gothique and so puts off on less sophisticated neighbors what he and his contemporaries viewed as barbaric style, disclaiming what in the nineteenth century would be accepted as the greater part of the glories of France's cultural past (see, for example, fig. 15, one of four beautiful late-Gothic illuminated miniatures from the workshop of the Boucicault Master included in the exhibition). In this, as in his theoretical outlook in general, Félibien followed Italian judgment, and he acknowledges the influence of Italian style—whether that of Rome or of Venice—on the French. Félibien, with his Italo-centric bias, does not mention the impact of Flemish painting on the French, but he does suggest the eclecticism of French artists, or, from a different perspective, their skill in imitating, assimilating, and blending differing styles in a way that undermines any attempt to identify a national style: "The French Taste has always been so divided that it is difficult to give a proper idea of it, since it seems that the painters of this nation have been rather different from each other in their works."[2]

At the time Félibien wrote, the paradigms for French artists were increasingly Italian works of the past rather than of the present, and even during Poussin's lifetime France began to gain a cultural ascendancy—an integral part of its rise to political and financial dominance—over not only Italy, but also the rest of Europe, that was relinquished only in the present century. Already in 1672, the Italian antiquarian, art theorist, and historian Giovan Pietro Bellori acknowledged the shift of artistic energy from Italy to France when he dedicated his *Lives of the Modern Painters, Sculptors, and Architects* (most Italian, all deceased) to the French minister Jean-Baptiste Colbert, who had been instrumental in the establishment or reformation of several academies in France and in the establishment of the French Academy in Rome. Typical of the literary genre, Bellori's dedicatory epistle fairly gushes with praise, but it suggests also the determined effort of the French:

> In placing before Your Excellency the Lives of the Painters, Sculptors, and Architects, I am guided by my most humble devotion, inspired by the benignity with which you have dedicated yourself to the protection of the most noble arts of design. Because you have been placed at the head of the monarchical spheres by the Providence of the Most Unvanquished and Glorious King Louis XIV, you oversee not only the greatness but also the ornament of the state, promoting the study of the best disciplines. Indeed, in your person their Maecenas is recognized by the fine arts, and their genius by painting, sculpture, and architecture, which, guided by your favor and taken by the hand to the royal throne, rise up exultant...[My pages] take flight more than anywhere else to the friendly districts of Paris, refuge of scholarship and arts, and fecund mother of talent; where among the glories of the armed and peaceable Pallas [Athena], with military discpline and excellence of arms, the athenaeums and the schools of science and letters flourish, and with them the Academy of the three arts of painting, sculpture, and architecture...[3]

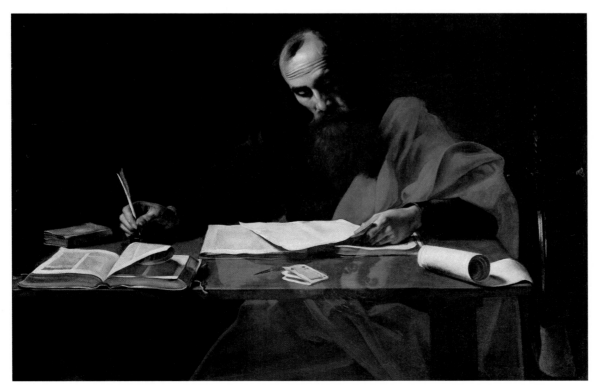

Fig. 16
Nicholas Tournier (1590 - 1657) or Valentin de Boulogne (1591 - 1632)
**St. Paul (St. Paul)**, c. 1625
oil on canvas, (39-1/8 in. x 52-3/8 in.)
The Sarah Campbell Blaffer Foundation, Houston, Texas

A practical purpose in establishing the French Academy in Rome was to have the students there copy and send to Paris the best works of ancient and Renaissance art; thus Colbert requested in 1679 from Charles Errard, the Academy's first director, an index "of all there is of beauty in Rome by way of statues, busts, ancient vases, and paintings, marking in the margin what you have already had copied and what remains to be copied, whether in painting or sculpture."[4]

Italian painters had come to France in the sixteenth century to enjoy royal patronage—most famously Leonardo da Vinci, Rosso Fiorentino, and Francesco Primaticcio, the latter two of whom were instrumental in establishing the long-lived, mannerist "School of Fontainebleau." French painters in turn made the pilgrimage to Rome, the source of modern art. It was the works of Caravaggio in Rome and of Annibale Carracci in Bologna and Rome from the two decades spanning the turn of the seventeenth century that eventually spelled the demise of mannerism in France as in Italy, although Caravaggio's painting had a much greater impact on art in the French provinces than in Paris itself. Caravaggio's dramatic tenebrism, plebeian figures, and ignoble still-life elements attracted a fervently devoted international following, especially intense in the decade after his death in 1610, and nowhere could his innovative painting be seen to better effect that in his series of paintings of Saint Matthew in S. Luigi dei Francesi, the French national church in Rome. *Saint Paul Writing His Epistles* (fig. 16) is patterned after Caravaggio's numerous half-length single-figure compositions (most notably the *Saint Jerome in His Study* of c. 1605 in the Galleria Borghese, Rome), and has been attributed to both Valentin de Boulogne and Nicolas Tournier. Valentin was born in the provincial French town of Coulommiers-en-Brie to a family of artists and artisans. He arrived in Rome probably before 1614 and remained there for the rest of his brief life, working for the Papacy, the papal family (the Barberini), and significant private patrons such as Cassiano dal Pozzo. Tournier, also a French provincial (from Montbéliard), had a career more typical of northern Caravaggisti in that he spent a few years in Rome (from at least 1619 to 1626), imbibing the new art of Caravaggio more than the glories of ancient and Renaissance Italy, after which he returned to his own country (in this case to southwest France). The *Saint Paul* is unusual in that it is actually three different compositions layered on the same canvas—perhaps a testimony to the poverty of an artist who was forced to reuse the support of apparently unsuccessful paintings. The first layer depicts a painter at his easel, presumably a self-portrait (visible through x-radiography); a Mocking of Christ was painted over it (the head of Christ is now visible, upside-

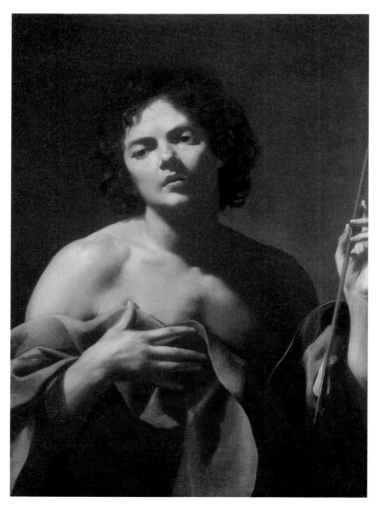

Fig. 17
Simon Vouet (1590 - 1649)
**St. Sebastian (St. Sebastien)**, c. 1618-20
oil on canvas, (37-3/4 in. x 29 in.)
The Sarah Campbell Blaffer Foundation, Houston, Texas

down, directly below Paul's left hand) but was subsequently covered by the *Saint Paul*. The Caravaggesque qualities of the *Saint Paul* include the simple composition; the very strong chiaroscuro (contrast of light and dark); the setting of the figure in a shallow, indeterminate space; and the subtle breaking of the picture plane with the open book at the left that projects over the edge of the table.

The *Saint Sebastian* of Simon Vouet (fig. 17) is equally Caravaggesque, though lacking the still-life elements of many such paintings. Vouet was born in Paris, the son of a painter, traveled widely— to England, Constantinople, and Venice—before settling in Rome by 1614. Here he, like so many other foreign artists of his generation, took up the style of Caravaggio. In spite of the international character of Caravaggism, and the continuing problem of assigning proper attribution to the paintings by Caravaggio's followers, there are, as Pierre Rosenberg has

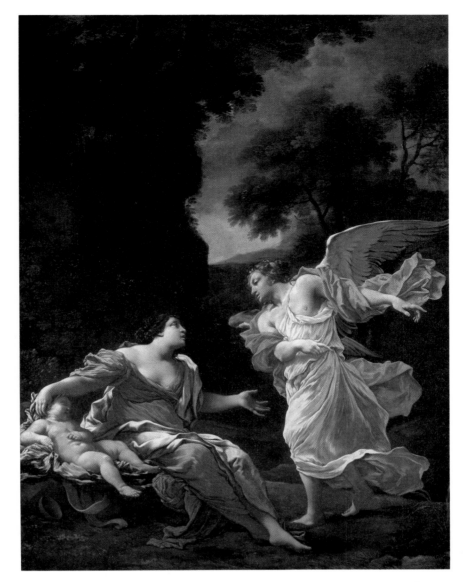

Fig. 18
Michel Dorigny (1617 - 1665)
*Hagar and the Angel (Hagar et l'ange)*, c. 1645-50
oil on canvas   (55-3/4 in. x 42-3/8 in.)
The Sarah Campbell Blaffer Foundation, Houston, Texas

pointed out, "certain features that can be designated 'French' in the works of Valentin and Vouet: restraint, sadness, and a love of elegance."[5]

These qualities are evident in the *Saint Paul* and the *Saint Sebastian*, both of which lack the more aggressively naturalistic and "vulgar" aspects of Caravaggio's work that were criticized by his contemporaries and later writers on art. The more subtle modeling of the *Saint Sebastian*, the avoidance of any more than the merest suggestion of the saint's gruesome martyrdom, the elegant gesture of the right hand, reminiscent of van Dyck, and the use of a lovely fuchsia in the drapery as well as in the saint's lips and eyelids—

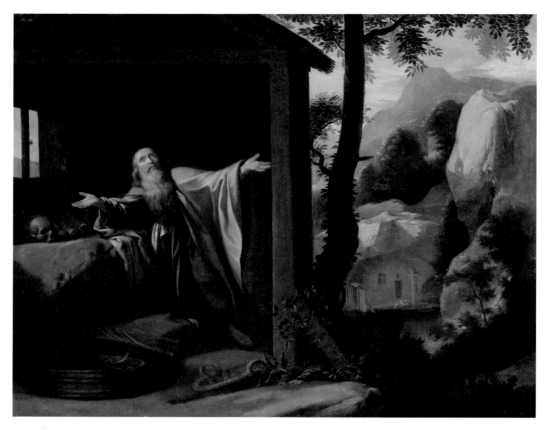

Fig. 19
Philippe de Champaigne (1602 - 1673)
**St. Arsenius Leaving the World (St. Arsenius quitte le monde),** c. 1650
oil on canvas,   (23-5/8 in. x 30-1/4 in.)
The Sarah Campbell Blaffer Foundation, Houston, Texas

these all suggest not only Vouet's particularly French version of Caravaggism, but also herald his own change of style in the 1620s, a turn toward the brighter tonalities, greater monumentality, and classicizing compositions of High Renaissance painting and its evocation in the work of Annibale Carracci (d. 1609) and his followers.

Unlike most of the Caravaggisti, Vouet had enormous public success. In 1618 he was granted a pension from the French king; in 1624 he was elected *principe* of the Roman Academy of St. Luke and received a prestigious commission for an altarpiece for St. Peter's in Rome. His numerous ecclesiastical commissions include altarpieces for churches in Rome, Genoa, and Naples. In 1627 he returned to Paris the most famous French artist of his day, and there he successfully continued his career. He trained several of the next generation's most important artists, including Charles Le Brun, and the year before his death in 1649 helped Le Brun found the French Academy (Académie Royale de Peinture et de Sculpture), the institution through which Le Brun dominated artistic life in Paris in the second half of the century. The pictorial style that Vouet established as the norm for history painters in Paris in the second quarter of the seventeenth century is evident in *Hagar and the Angel* of c. 1650 (fig. 18), by Vouet's son-in-law, Michel Dorigny, whose paintings have often been confused with those of Vouet himself. The crepuscular lighting, though intense, is not harshly Caravaggesque, the figures are monumental but elegantly posed, and the patterns of line and color created by the draperies manifest a strongly decorative sensibility.

Although French painting (and the theoretical premises on which it was based) was in the seventeenth and eighteenth century tied closely to that of Italy, it always maintained a stylistic independence, and, as Félibien recognized, there was considerable diversity within the *Goût François*. A major factor in this diversity was Flemish painting. Peter Paul Rubens was the most famous Fleming in France during his visits to arrange the commission and the installation of his series of heroic paintings on the life of the queen mother, Marie de Médici, for the Palais de Luxembourg (1622–1625). However, the effect of those paintings on French art would be felt only much later, most notably in the work of Watteau. In the meantime, numerous other Flemish and Dutch painters who spent time in Paris, briefly (such as the still-life painter Willem Kalf) or for their entire careers, helped shape French painting in all its variety.

One of the most successful painters of seventeenth century France was Philippe de Champaigne. Born and trained in Brussels, he came to Paris in 1621 and spent the rest of his long life there. Notably, he never journeyed to Italy. He worked for Louis XIII, Cardinal Richelieu, and extensively for the church and was official painter for the magistrates of Paris. A founding member of the French Academy, he was later named its *recteur*. His *Saint Arsenius Leaving the World* (fig. 19), a rare depiction of an obscure desert father, exemplifies the Flemish characteristics of Champaigne's work: polished surfaces, fineness of detail, a lack of monumentality in the figure, and, most obviously, a formulaic, blue-tinted landscape in the tradition of Joachim Patinir. Here we are poles apart from Dorigny's Italianate *Hagar and the Angel*.

## THE ACADÉMIE ROYALE DE PEINTURE ET DE SCULPTURE

Since at least the thirteenth century, the visual arts in Paris had been practiced according to the rules of a guild, called the Maîtrise (Mastership), which determined who could pursue the included professions, set the length of required apprenticeship, regulated the importation of works by foreign craftsmen, and restricted the maintenance of a public shop to guild members. Only a few artists, by virtue of royal position, could operate outside the guild. In an effort to free themselves from the rather oppressive guild restrictions, a number of mostly young artists in Paris, led by Le Brun fresh from a sojourn in Italy, sought the protection of the king and founded the Royal Academy of Painting and Sculpture in 1648.[6] Following Italian examples, especially the Florentine Accademia del Disegno and the Roman Accademia di San Luca, the French Academy was grounded on humanistic principles which asserted that painting and sculpture were essentially intellectual rather than manual endeavors, liberal arts *(arts nobles)* rather than crafts *(arts mécaniques)*, and that artists therefore should not be members of a guild that included artisans. In the Academy, artists were to be trained in anatomy, perspective, and history and to participate in discussions on the "difficulties of Art." Regardless of the eventual social and political importance of the Academy, its primary function remained the education of artists. Disagreement between Academicians on theoretical matters was common—most famously between the Rubénistes, who argued for the primacy of color in the tradition of Rubens, and the Poussinistes, who stressed drawing or design (*dessin*, corresponding to the important Italian concept of *disegno*) in the tradition of Poussin. But the ultimate goal of academic discussions and lectures was the provision of precepts for the making of good art, precepts whose apparent inflexibility have made them repugnant to later critics.

In 1654 a new code of rules was drawn up that included the prohibition of life-drawing outside the Academy, thus making it nearly impossible for any non-Academician to engage in the more prestigious genres of history painting and portraiture. For years the Academy struggled with virtually no assistance from the king or his ministers and was constantly embattled with the *Maîtrise*, which rightly recognized the threat to its authority. It was Colbert, elected as vice-protector of the Academy in 1661 and protector in 1672, who enabled the Academy to become an institution without parallel in its domination of the artistic

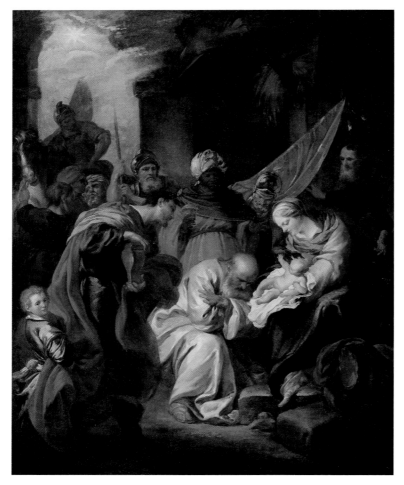

Fig. 20
François Le Moyne (1688 - 1737)
**The Adoration of the Magi (*L'Adoration des rois mages*)**, 1716
oil on canvas, ( 39-1/4 in. x 32 in. )
The Sarah Campbell Blaffer Foundation, Houston, Texas

life of a nation. Colbert guaranteed funds to pay the salaries of the Academy's professors and rectors, to pay for the models and student prizes. Furthermore, the requirement that all painters to the king participate in the Academy effectively reserved all royal commissions to Academicians, and other public schools were prohibited in favor of the Academy. Colbert's establishment of the French Academy in Rome in 1666 was the event that incited Bellori's lavish praise quoted above. Although most of Colbert's successors were less enthusiastic about the political efficacy and efficiency of the Academy—and therefore simultaneously less supportive of its endeavors and less interested in controlling it—the Academy remained firmly established as an institution of considerable influence and power. This influence was enacted on a public stage with the Salons, exhibitions of works by Academicians, envisioned from the foundation of the Academy but held only sporadically until 1737, after which they became regular events, for a short time annually and then semi-annually.[7] Written criticism, usually in the form of published pamphlets, proliferated around the Salons—beginning with La Font de Saint-Yenne in 1747—and constituted an important link between the Academy and the Parisian public.

The benefits of membership in the Academy (including exemption from military duty) were so great after its reorganization in 1662 that very few French artists of note attempted to operate outside of it. [8] Some artists, such as Jean-Baptiste Oudry and Jean-Siméon Chardin, debuted with the *Académie de Saint-Luc*, the eighteenth century successor to the *Maîtrise*, but subsequently entered the Royal Academy to satisfy their professional ambitions. In order for a painter to become a member of the Academy, he (or, rarely, she) had to complete adequate training—including, if possible, study in Rome—and then present a work for approval to the members of the Academy. If the artist was approved *(agréé)*, based on the quality of the work, he then prepared a special work, the *morceau de réception*, the subject of which was specified by the Academy. François Lemoyne's *morceau d'agréement* (fig. 20) was approved in 1716, as described in the

records of the Academy: "François Lemoyne, painter, born in Paris, presented a painting representing an Adoration of the Kings, in order to be *agréé*. The Company approved his presentation by the usual voice vote; he will receive from M. Coypel, the Director, the subject for his reception piece, and he will be given six months to fulfill [the assignment]."[9] (It was not until 1718 that Lemoyne presented the requested *Hercules Killing Cacus*.) Again, with the demonstration of an adequate level of ability in the *morceau de réception*, the artist was received *(reçu)* as an Académicien. Honorary memberships were also granted to respected writers on art, beginning with Bellori in 1689.

The subject of the *morceau de réception* was related to the category of entrance, as explained by Félibien: "When the Academy receives someone, he is admitted into the Company in painting or in sculpture, and painters are received according to the talent that they have in painting; [the Company] makes distinctions by the Letters that it gives: those who work in history from those who do only portraits, or battle-scenes, or landscapes, or animals, or flowers, or fruits, or even those who paint only miniatures, or those who engage particularly in engraving, or another group concerned with drawing."[10] Thus the painter was admitted according to medium (painting, sculpture, printmaking) but also, and more important, according to the genre in which he worked. The Academy's taxonomy of genres was highly flexible: while it included the obvious categories (*peintre d'histoire, peintre de genre, peintre de portrait*, and so on), it also allowed for the invention of new ones (*peintre de fêtes galantes*, created to accommodate Watteau) or ostensibly specialized ones (*dans le talent de...*["in the talent of..."]).[11] The category of specialist was a particularly amorphous catch-all, offering the possibility of rather eccentric qualifying remarks, and an example should suffice as a warning against reading too much into the distinctions of genre drawn by the Academicians: the unfortunately short-lived follower of Watteau, Bonaventure de Bar (fig. 21) was received into the Academy "in the particular talent of the figure like Teniers and Wouwerman,"[12] a description that rightly acknowledges the Flemish heritage to his work, but otherwise provides little indication of the nature of his art.

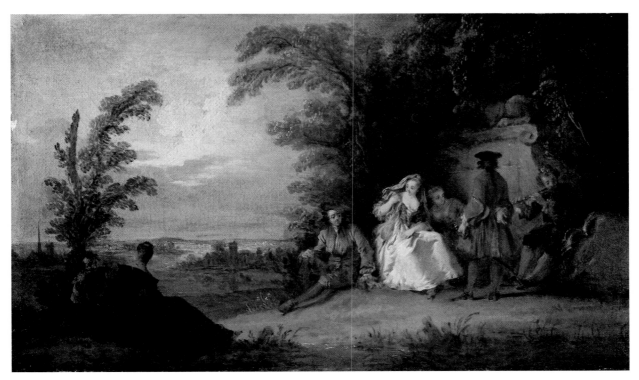

Fig. 21
Bonaventure de Bar (1700 - 1729)
**Country Fair (Fête champêtre),** late 1720s
oil on canvas, (7 in. x 11-1/2 in.)
The Sarah Campbell Blaffer Foundation, Houston, Texas

### THE GENRES IN FRENCH PAINTING

Although the taxonomy of pictorial genres was neither precise nor fixed, it was of considerable significance in that it privileged the painter of histories over other artists in a hierarchy of importance. References to the hierarchical categories of subjects used in the Academy appear sporadically in the seventeenth and eighteenth centuries, but they represent the codification of theoretical precepts already operative much earlier in France and elsewhere, precepts based on a humanistic art theory that was established in broad outlines in Italy in the fifteenth century and adumbrated ad infinitum through the sixteenth and seventeenth centuries. One of the earliest and most influential statements on the genres in France can be found in Félibien's *Conférences de l'Academie Royale de Peinture et de Sculpture* of 1669, which, significantly, was republished a century later during the height of the Salon exhibitions. Though well known, it bears repeating here:

> In this Art there are different workers who apply themselves to different subjects; it is consistent that to the degree they occupy themselves with the most difficult and most noble things, they leave behind that which is most low and most common, and ennoble themselves by means of a more illustrious undertaking. Thus he who does landscape perfectly is above another who does only fruits, flowers, or shells. He who paints living animals is more noteworthy than he who represents only those things that are dead and motionless; and since the figure of man is the most perfect work of God on Earth it is also certain that he who makes himself the imitator of God in painting human figures, excels much more than all the rest. However, no matter that it is no mean feat to make the figure of man appear as if living, and to give the appearance of movement to that which has none at all; all the same a painter who does only portraits has not yet attained perfection of the art, and cannot look forward to the honor that the wisest will receive. For this [honor], one must pass from the single figure to the representation of several figures together; one must treat history and fable; one must represent great deeds as do historians, or pleasant subjects as poets do; and rising higher still, one must know how, through allegorical composition, to clothe beneath the veil of myth the virtues of great men, and the most exalted mysteries. One calls him who acquits himself well of such undertakings a great painter. In this lies the force, the nobility, and the grandeur of this art, and it is this in particular that one must learn early, and that one must teach to students.[13]

Like virtually every early modern writer on art, Félibien grounds his theory on an Aristotelian bias in favor of the depiction of important human actions, representing men as better than they are and, in the process, ennobling the viewer. This point of view achieves its virtual apotheosis in the middle of the eighteenth century with the critic La Font de Saint-Yenne:

> History painting is indubitably the highest genre of painting. Only the history painter is the painter of the soul, the others only paint for the eyes. Only he can set to work that enthusiasm, that divine fire which makes him conceive his subjects in a strong and sublime manner: only he can shape heroes for posterity, by presenting to their eyes the great actions and the virtues of famous men, not by the cold means of reading, but by the very sight of the facts and the actors.[14]

Within the Horatian dictum that the arts should both instruct and please, La Font emphasizes the former, available by and large only in history painting. The didactic function of painting was made clear by the minor painter Charles Alfonse du Fresnoy in his influential Latin poem *de Arte Graphica*, composed during the author's Roman sojourn in the 1630s and 1640s, but first published in Paris in 1667 (here in the eighteenth-century English translation of the poem, which was annotated by Sir Joshua Reynolds, president of the Royal Academy in London):

> Some lofty theme let judgment first supply,
> Supremely fraught with grace and majesty;
> For fancy copious, free to ev'ry charm
> That lines can circumscribe or colours warm,
> Still happier if that artful theme dispense
> A poignant moral and instructive sense.[15]

The lofty theme belongs naturally to history painting. Such theoretical precepts had very real practical applications: from 1664 the professors, rectors, and directors of the Academy, as well as students at the French Academy in Rome (from 1666), could be only history painters (or sculptors), and prices paid for works destined for the royal collection were weighted in favor of history paintings.

As adamant as La Font and other French critics and art theorists were about the nobility of history painting and its primarily didactic function, pleasure is the motivating factor in much of it ( fig. 14), and certainly in most works in the other genres. The Academy did not seem to distinguish between more or less serious history paintings. Thus François Boucher, in seeking promotion within the Academy in 1735, submitted "four little pieces, depicting the four Seasons in the shape of little women and children, which were found very fine, as much for their striking color, modeling, and brushwork, as for their charming conception,"[16] rather like the *Cherub Harvesters* (fig. 25). He received an associate professorship. Sensing that history painting had lapsed into a decorative complacency out of keeping with its supposedly high purpose, the Duc d'Antin in 1727 organized a royal competition whose purpose was to reinvigorate history painting. Even here most of the paintings, including Jean-François de Troy's *Diana Reposing* (which shared first prize with François Lemoyne's more seriously moralizing but still richly decorative *Continence of Scipio*) and Noël-Nicolas Coypel's well-received *Rape of Europa*, were more about the female nude than noble acts of human virtue. The competition was, in any case, not a success, but in 1747 the reform-minded *directeur des bâtiments*, Le Normand de Tournehem, tried it again in order "to revive the art, which seems to have fallen not

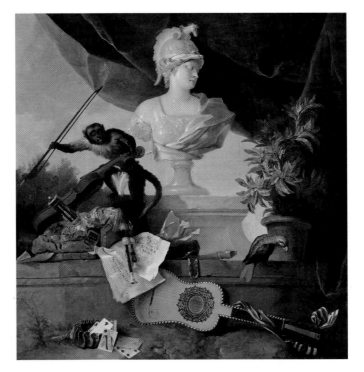

Fig. 22
Jean-Baptiste Oudry (1686 - 1755)
***Allegory of Europe (Europe, figure allégorique)***, 1722
oil on canvas, (63-3/4 in. x 59-3/4 in.)
The Sarah Campbell Blaffer Foundation, Houston, Texas

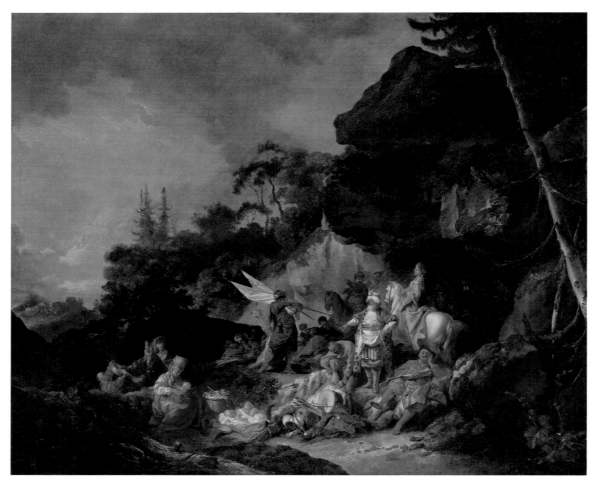

Fig. 23
Jean-Baptiste Leprince (1734 - 1781)
**The Tartar Camp (La Halte des Tartares)**, c. 1765
oil on canvas, (69 in. x 87-3/4 in.)
The Sarah Campbell Blaffer Foundation, Houston, Texas

only in France, but even in countries where painters formerly excelled in this genre."[17] The results were scarcely better, and in the Salons of the eighteenth century fanciful and erotic types of mythology outnumbered serious mythologies by several times, even during the neoclassicizing nationalist fervor of the Revolution.[18]

Because the theoretical primacy and professional prestige attached to history painting was significant, it is not surprising that some artists made efforts to be received into the Academy in history painting, a broadly inclusive category, when their true occupation lay elsewhere. Thus in 1719 Oudry, one of the best animal and still life painters of the eighteenth century (see fig. 22), submitted as his *morceau de réception* a large allegory of *Abundance* (Versailles, Musée National du Château de Versailles),[19] which, owing to the presence of the human figure and the classicizing allegory, enabled him to enter the Academy as a *peintre d'histoire*. Jean-Baptiste Greuze presented himself in 1769 as a history painter by submitting a painting of an exalted subject—*Septimus Severus and Caracalla* (Paris, Louvre), but was received as only a *peintre de genre*; he was so dismayed by the affront that he did not submit any works to the Academy's official Salon until 1800.

Most paintings from the seventeenth and eighteenth centuries fit comfortably into the genres recognized by the Academy and described in contemporary art literature. Yet, in spite of a stratification of the genres, whether explicit or implicit, the lines between them remained tenuous and fluid. Most artists, while generally identified with a particular genre, worked also in others. Carle van Loo and Boucher are perhaps the most flexible in this regard; although primarily history painters, they were equally adept at landscape, portraiture, and genre (granted that the latter is of a particularly fanciful kind). Many paintings are poised between two or more genres: for example, Jean Lemaire's *Mercury and Argus* (fig. 35) is both landscape and history (mythology); Jean Michelin's *The Poultry Sellers* (fig. 32) is genre and still life; Jean-Baptiste Leprince's *The Tartar Camp* (fig. 23) is landscape and genre, with a touch of the exotic added. Laurent de La Hyre's *Allegory of Scientific Experiment* (fig. 24) is a history painting, and Jean-Baptiste Oudry's *Allegory of Europe* (fig. 22) is a still life, but they are very similar in content—the major difference is that La Hyre's painting includes fewer inanimate objects (but more landscape) and the central figure is slightly more *vivante* than Oudry's marble bust of Europe. Boucher's *The Cherub Harvesters* (fig. 25), one of a set of four paintings with pseudo-mythological figures in a landscape with possible allegorical significance, has antecedents in ancient, Renaissance, and Baroque art, but is fundamentally a new genre that defies categorization.

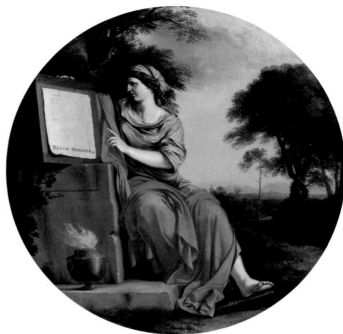

Fig. 24
Laurent de la Hyre (1606 - 1656)
***Allegorical Figure of Geometry***
***(La Géométrie, figure allégorique)***, 1650
oil on canvas, (circular, 41-1/2 in. diameter)
The Sarah Campbell Blaffer Foundation, Houston, Texas

The official position on history painting, particularly of the more serious variety, was not in keeping with its public popularity (or relative lack of it). Given the great emphasis placed on history painting by the Academy, its governmental supporters, and many critics of the Salons, it may seem surprising that in the Salon exhibitions, paintings in the so-called nonpublic or lower genres vastly outnumber history paintings, or the public genres, even by as much as three or four to one.[20] They were generally smaller and could therefore be executed more quickly and less expensively, and they were much less limited in their market than large history paintings. Of the lower genres, portraits and landscapes dominated the Salons.

Fig. 25
François Boucher (1703 - 1770)
***The Cherub Harvesters (Les Amours moissonneurs)***, c. 1733-34
oil on canvas, (49-1/2 in. x 37-1/2 in.)
The Sarah Campbell Blaffer Foundation, Houston, Texas

## HISTORY PAINTING

The various branches of this noblest of genres—religious, classical (both history and mythology), and allegorical—were interchangeable for most history painters. The subject of an artist's *morceau d'agréement* might be religious while that of his *morceau de réception* would be mythological (Lemoyne is an example), and in the course of an artist's career the type of subject per se would most likely not influence his enthusiasm for a commission nor even necessarily affect the manner in which he painted it.

The most important French history painter of the seventeenth century was Nicolas Poussin, but his influence was exercised from afar—he only reluctantly responded to a command to return to Paris from Rome in 1640 to enter the royal service, and he stayed as short a time as possible. Returning to Rome with Poussin in 1642 was Charles Le Brun, who had trained in the studios of François Perrier and Simon Vouet, both of whom had had lengthy and productive stays in Italy. After working with Poussin in Rome, Le Brun returned to Paris in 1646 and embarked on a career of unparalleled success. Almost immediately he received important commissions for ecclesiastical works and then for the kind of large-scale secular decoration that best suited his talents (including that of the château of Vaux-le-Vicomte for Nicolas Foucquet from 1658 to 1661). Named *premier peintre* to the king in 1664, and serving as director of both the Academy he was instrumental in founding and the Gobelins tapestry factory, he executed most of the major pictorial decoration for the royal palaces—the Galerie d'Apollon in the Louvre, and, at Verailles, the Escalier des Ambassadeurs, the Galerie des Glaces, the Salon de la Guerre, and the Salon de la Paix. Le Brun enjoyed immense power and influence in matters pertaining to art until the death of Colbert in 1683, when he was eclipsed by his long-time rival, Pierre Mignard.

Unlike Poussin, Le Brun embraced the opportunity to direct the artistic affairs of his country, and in so doing attempted to put into large-scale practice, through the Academy, the lessons learned from Poussin. His unfinished *Road to Calvary* (fig. 26) adapts, in reverse, a compositional sketch by Poussin (datable to 1646) for a painting never executed. Le Brun's painting was probably begun in Rome and possibly left there unfinished on the artist's return to Paris. There are in the Cabinet des Dessins of the Louvre several preparatory drawings for the figures. These demonstrate at an early stage in his career Le Brun's adoption of a working method based on *disegno* in the tradition of Raphael—a practice with theoretical precepts to support it that he would advocate later in the Academy. The attention to expression in the faces and gestures—the *affetti*, motions of the body understood as revealing the motions of the soul—so important to Renaissance and Baroque art theory, is evident even in the sketchy state of the painting: the forbearance of Christ, the sorrowful solicitude of Saint Veronica proffering her veil, the anguish of the Virgin as she looks over her shoulder at her fallen son, the cruelty of the mounted soldier at the right, who directs the operation. In this the painting recalls not only the work of Poussin, but also Guido Reni's famous *Saint Andrew Led to Martyrdom* of 1609 (Oratorio di Sant'Andrea, San Gregorio Magno, Rome), which was equally decisive for *The Road to Calvary* in the general disposition of figures in the landscape. Le Brun's interest in expression culminated in lectures to the Academy, illustrated with drawings, and the composition of a manuscript, the *Traité de la passion*, which was published posthumously in 1698, accompanied by engravings drawn from Le Brun's work. Le Brun's comments on expression, with detailed how-to rules on depicting it in painting, have been a lightning rod for criticism of an unduly prescriptive, inflexible, "academic" approach to the making of art, but they exemplify his practical concern for the education of young artists in the Grand Style.

In his day, Charles-André van Loo, called Carle (1705-1765), was widely recognized as the "first painter in Europe" and exemplifies the aspirations (and limitations) of French history painting in the eigh-

Fig. 26
Charles Le Brun (1619 - 1690)
**The Road to Calvary (La Route à Calvarie)**, c. 1645
oil on canvas, (57 in. x 77 in.)
The Sarah Campbell Blaffer Foundation, Houston, Texas

teenth century. Treated unkindly in modern scholarship (Michael Levey calls him "deeply stupid and uncultivated" and no more than a "dutiful but basically uninventive artist"),[21] Carle was almost universally esteemed (with occasional caveats) by his contemporaries, including such diverse critics and writers as Diderot, Caylus, La Font de Saint-Yenne, Voltaire, and Friedrich Melchior Grimm, and he reached the top of his profession. Born in Nice to an expansive artistic family of Flemish origins, he received his initial training from his much older brother Jean-Baptiste, who worked in Italy (at Rome, Genoa, and the court of Turin) during 1712–1715 and 1716–1718. During the latter period, Carle received further training in Rome from the painter Benedetto Luti and the sculptor Pierre Legros. The two brothers returned to France around 1720, and Carle became a pupil at the Academy, the institution within which he worked in paradigmatic fashion until his death forty-six years later. Jean-Baptiste had stressed drawing as the foundation of his brother's education, and in the Academy van Loo won first a medal for drawing and then in 1724 the prestigious Prix de Rome for painting. As a result, he returned to Rome in 1728 (a lack of royal funds

Fig. 27
Henri-Antoine de Favanne (1668 - 1752)
**Athena Protecting Alexander the Great Before Darius (Athèna défend Alexandre devant Darius)**, c. 1725
oil on canvas, (37 in. x 49-1/2 in.)
The Sarah Campbell Blaffer Foundation, Houston, Texas

caused the delay, and van Loo financed his own trip). Now as a member of the French Academy there, he won another first prize for painting. A measure of van Loo's public success was the commission in 1729, in spite of his youth and the fact that he was a foreigner, to fresco the vault of the Roman church of San Isodoro. After steeping himself fully in the traditions of Roman painting from Raphael to Carlo Maratti and working in Turin from 1732 to 1734, van Loo returned to Paris where he was *agréé* at the Academy in 1734 and received as a member in 1735 with a *morceau de réception*, remarkably, of his own choosing (an Apollo Flaying Marsyas). Because most of van Loo's rivals (with the notable exception of Boucher) disappeared from the scene for one reason or another, and van Loo continuously produced enormous paintings of elevated (especially religious) subject matter, he gradually achieved the status of leading painter in France and, in Grimm's words, *premier peintre d'Europe.* He became, in turn, governor of the newly created École des élèves protégés in 1749, *premier peintre* to the king in 1762, and, in 1763, director of the Academy in Paris.

In addition to his large-scale religious works, van Loo produced mythological paintings, portraits, landscapes, and mildly exotic genre scenes (like *Grand Turk Giving a Concert* of 1737, London, Wallace Collection). Shortly after his return to Paris in 1734 he worked with several leading painters—including Boucher and Natoire—on the decoration of the Hôtel de Soubise, where charming mythological scenes of the gods in love are set in delicately organic architectural ornament, representing the quintessence of Rococo style and the clearest legacy of eighteenth-century French art.[22] Van Loo had already demonstrated his ability in this mode in his *Mars and Venus* (fig. 14), painted around 1730 while he was still in Rome, as well as in a series of iconographically similar works for the bedroom of the queen of Sardinia at the palace of Stupinigi near Turin. In the Mars and Venus, the two gods lounge on nebulous cushions and gaze into each other's eyes. The warrior god's weapons are discarded at the bottom of the scene, and the inscription on a contemporaneous engraving by Simon-François Ravenet after the painting attempts, somewhat desperately, to find a serious (if somewhat murky) message in the picture: "In yielding to Love, the most valiant warriors, far from withering their laurels, augment them. The God Mars abandons himself to the joys of Venus. We will fear to follow the example he gives us." (En cédant à l'Amour les plus Vaillans guerriers / bien loin de les fletrir augmantent leurs Lauriers / au douceurs de Venus le Dieu Mars s'abandonne / Craindrons nous d'imiter l'Exemple qu'il nous donne.) But any possible epigrammatic meaning, and even Mars himself, who virtually melts into the like-tinted background, are secondary to the painting, which revels in the nudity of the inconstant goddess of love, who leans languidly back, open to the viewer, her opalescent flesh and roseate toes, knees, breasts, and cheeks contrasting with the cool blues and greens of the sky and Mars's clothing and armor. This use of the antique for erotic purposes obviously owes much to Venetian painting but has precedents also in Poussin, whose earlier works, including the subject of *Mars and Venus* (Boston, Museum of Fine Arts), followed Venetian examples in a more poetical engagement with mythological subjects. It was an aspect of Poussin generally lost in the debate between the Rubénistes and Poussinistes, in the rhetoric of the Academy, which exalted Poussin as the paragon of serious history painting, but it was clearly not lost on his multifarious artistic progeny through the eighteenth century.

This more official side of Poussin—his severe neoclassical compositions, in austere if sophisticated color schemes, of morally ennobling scenes of biblical and ancient history (as opposed to mythology)—was to be fully revivified only at the end of the eighteenth century by David. But it echoes repeatedly, if weakly, through the century after his death in 1665, often mediated through the more discursive and melodramatic work of Le Brun. Thus Henri-Antoine de Favanne's *Athena Protecting Alexander before Darius* (fig. 27), though contemporary with van Loo's *Mars and Venus* and likewise an antique subject, is a polar opposite in style and function. Disposed across the canvas as in a classical bas-relief (Athena is seen frontally and Alexander in perfect profile), the figures engage in heroic action, their gestures demonstrative and frozen, as if stiffness of form could convey seriousness of purpose and strength of ideas.

## PORTRAITURE

Through the first three-quarters of the seventeenth century, portraiture in France adhered to a Flemish tradition of precise detail and highly finished surfaces, factual topographies of the sitters' countenances and appurtenances, which is evident in the sixteenth-century *Portrait of a Woman* by Corneille de Lyon (fig. 28)—virtually a miniature in scale and sensibility—and in the work of the most important portraitist of the period, Philippe de Champaigne, whose primary work was, in the eyes of his contemporaries, history painting. Champaigne's monumental and sober portraits and the more dynamic full-length portraits by Rubens and van Dyck formed the basis for the most grandiose of French state portraits, Hyacinthe Rigaud's *Louis XIV* of 1701 (Paris, Louvre). Public portraiture tended to be conservative and convention-

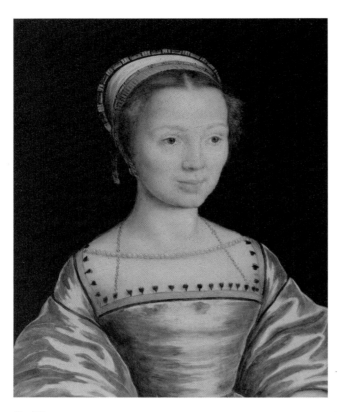

Fig. 28
Corneille de Lyon (c. 1500 - 1574)
**Portrait of a Woman (Portrait d'une femme)**, c. 1540s
oil on panel, (6-3/8 in. x 5-1/4 in.)
The Sarah Campbell Blaffer Foundation, Houston, Texas

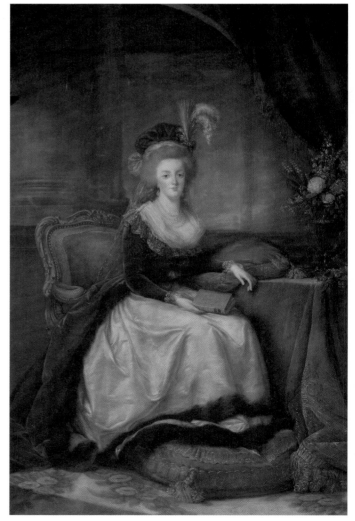

al, and the same Baroque devices are repeated throughout the eighteenth century. In spite of the lack of military ambition that characterizes the reigns of Louis's successors, royal portraiture remained equally imposing in scale and sumptuousness. Even in the final years of the decaying *ancien régime*, Marie-Antoinette appears self-assured in a giant pastel, a medium generally employed for more intimate portrayals (fig. 29; after a portrait in oil by Elizabeth-Louise Vigée-Lebrun at Versailles).

Fig. 29
Circle of Vigée-Lebrun, (18th Century)
**Portrait of Marie Antoinette (Portrait de Marie Antoinette)**, c. 1788
pastel, (100 in. x 67 in.)
The Sarah Campbell Blaffer Foundation, Houston, Texas

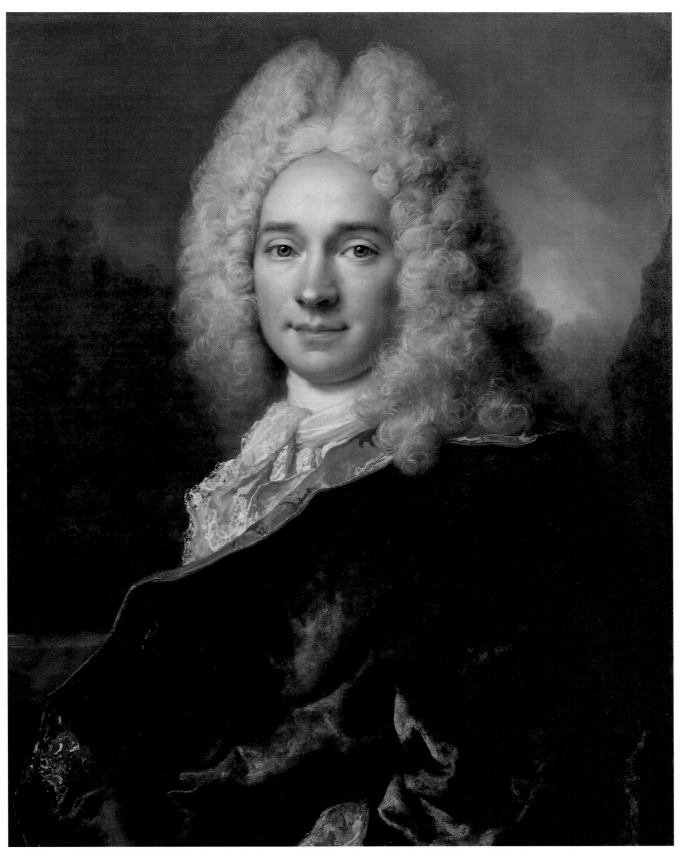

Fig. 30
Nicolas Largillière (1656 - 1746)
*Portrait of Pierre Cadeau de Mongazon (Portrait de Pierre Cadeau de Mongazon)*, c. 1720s
oil on canvas, (32 in. x 25-1/2 in.)
The Sarah Campbell Blaffer Foundation, Houston, Texas

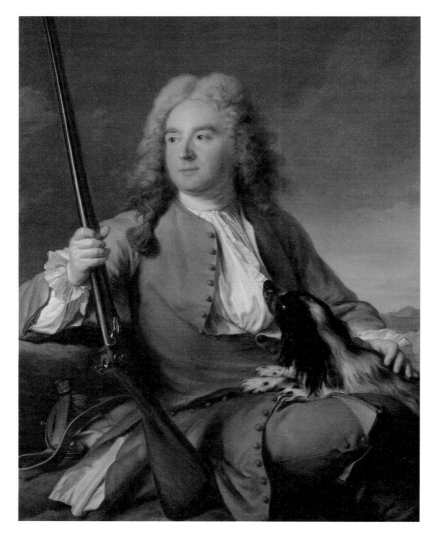

Fig. 31
Jean Marc Nattier (1685 - 1766)
**Portrait of a Gentleman Hunter**
**(Portrait d'un gentilhomme en chasseur)**, 1727
oil on canvas, ( 46 in. x 35-1/2 in.)
The Sarah Campbell Blaffer Foundation, Houston, Texas

Apart from the ceremonial portraits *(portraits d'apparat)*, images of the wealthy, whether noble or bourgeois, could be more intimate in treatment, both in their scale and in the more informal attire and gestures of the sitters. Equally adept in both modes were Rigaud and his contemporary and friendly rival, Nicolas de Largillière, who were the two leading portraitists under Louis XIV, and whose very long careers continued productively into the middle of the eighteenth century. Largillière was trained first in Antwerp and then in London, and his work not surprisingly owes a great deal to the portraiture of van Dyck and Rubens (and, through them, of Titian). In his *Portrait of Pierre Cadeau de Mongazon* (fig. 30) the colorism of this tradition is apparent: the textures and patterns of the lace, wig, and jacket are suggested by flickering lines, and the soft brushwork lends atmosphere to the landscape background and life to the face.

Jean-Marc Nattier carried the informal approach to portraiture into the second half of the eighteenth century. In his early *Portrait of a Gentleman Hunter* (fig. 31) of 1727 the trappings of aristocracy—the hunting dog and gear—are part of a tradition stretching back to the sixteenth century, while the studied disarray of the jacket and wig and the casual pose in a landscape recall works of Rigaud and Largillière. Nattier was an enormously successful painter of fashionable Parisian women, whom he managed to present as charming and attractive though also frequently vacuous, regardless of their actual appearance. Nattier was originally received into the Academy in 1718 as a history painter, but having lost a great deal in the financial collapse of 1720, he turned to portraiture as a more lucrative alternative. Nattier's change of direction was successful not only because he was talented, but also because there was such a high demand for portraiture in the eighteenth century; portraits could be completed relatively rapidly, and thus economically. Even though history painting was officially privileged over portraiture, and prices for royal commissions were scaled heavily in its favor, the attractions of the other genres were too great for many artists to resist. Nattier walked the line between history painting and portraiture by painting many of his sitters, especially women, in allegorical guise. The occasional excesses of these *portraits histories* drew the criticism of some writers; Nattier's daughter and biographer retorted that "He reconciled the two major branches of art in his works, so that the informed public did not know which to admire more in him—the history painter or the portraitist."[23]

## GENRE PAINTING

French Caravaggisti frequently adopted and expanded Caravaggio's repertoire of genre subjects—fortune tellers, music parties, fruit vendors, and so on. But Caravaggism was never a Parisian phenomenon, and genre painting in the French capital developed in a different direction. A remarkable triumvirate of brothers—Antoine, Louis, and Matthieu Le Nain—came to Paris from Laon by 1629 and created an impressive series of paintings of stately peasants in both exterior and domestic interior settings. The Le Nain brothers fully participated in the artistic life in Paris (all three were present at the inaugural meeting of the Academy in 1648, although Antoine and Louis died shortly thereafter). However, more than their contemporaries, they and their apparently native French painting were important to French nationalist concerns in the nineteenth century, when they were "rediscovered." Félibien, who includes them in a list of notable painters, comments with characteristic bias only that they "painted stories [*histoires*] and portraits, but in an ignoble manner, representing often poor subjects."[24] Nonetheless, the Le Nain brothers did have their followers, including Jean Michelin, who was received as an Academician in 1660. He frequently depicted the practitioners of minor professions, a genre common throughout Europe in the seventeenth century (e.g., the eighty etchings after the Carracci drawings known as the *Arti di Bologna*), but usually in the less expensive form of prints. Michelin's *Poultry Sellers* (fig. 32), a subject he explored a number of times, though relatively small in size, is a monumental portrayal of a family of simple vendors, ragged but dignified, as motionless as their dead wares. The color scheme tends toward the monochromatic, and the surface in no way entrances the viewer with a sensuous application of paint; rather, the market to which this picture appealed was concerned entirely with subject matter, presented in as straightforward and verisimilar way as possible.

Félibien's criticism of the Le Nain brothers is an unexceptional part of a theoretical point of view with both Aristotelian and Platonic origins that had been current since the fifteenth century: that people, animals, landscapes, objects—Nature itself—should be idealized in art, depicted not as they are in actuality but perfected according to an ideal, as Nature herself would have made them were she not impeded

by the corruptibility of the matter with which she worked. The touchstone for the idealization of the human figure was classical sculpture, as evident in Du Fresnoy's influential formulation. The union of Nature and the Ancients in favor of a higher beauty is clearly expressed:

> Tis Painting's first chief business to explore,
> What lovelier forms in Nature's boundless store,
> Are best to Art and ancient Taste allied,
> For ancient Taste those forms has best applied.[25]

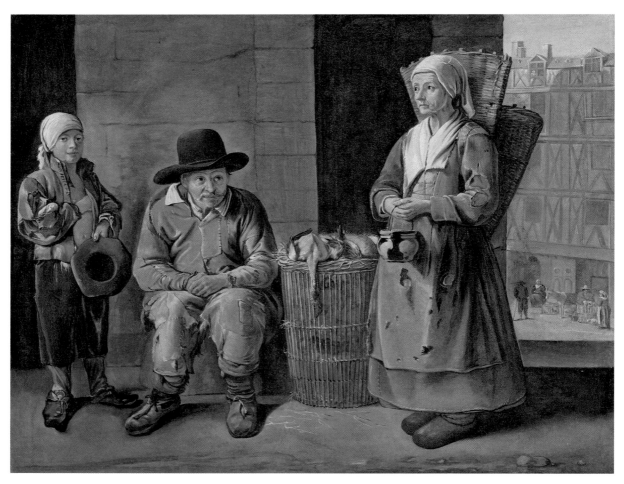

Fig. 32
Jean Michelin (1623 - 1696)
**The Poultry Sellers (Les Vendeurs de volaille)**, c. 1660s
oil on canvas,  (25-5/8 in. x 32-5/8 in.)
The Sarah Campbell Blaffer Foundation, Houston, Texas

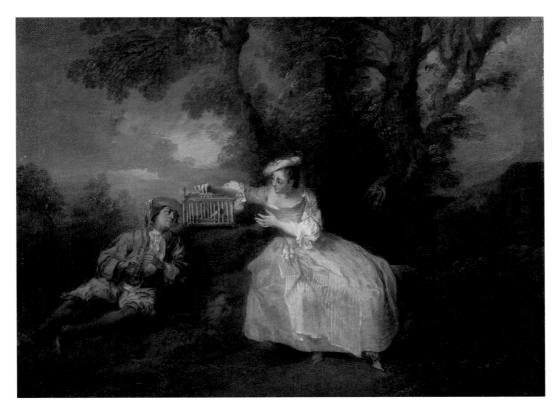

Fig. 33
Nicolas Lancret (1690 - 1743)
**The Captive Bird (L'Oiseau prisonnier)**, c. 1730
oil on canvas, (11-5/8 in. x 15-5/8 in.)
The Sarah Campbell Blaffer Foundation, Houston, Texas

Du Fresnoy hails Nature as the source and arbitress of art, but warns against its superficial beauties that are still not perfect:

> When first the orient rays of beauty move
> The conscious soul, they light the lamp of love,
> Love wakes those warm desires that prompt our chase,
> To follow and to fix each flying grace:
> But earth-born graces sparingly impart
> The symmetry supreme of perfect art;
> For tho' our casual glance may sometimes meet
> With charms that strike the soul, and seem compleat,
> Yet if those charms too closely we define,
> Content to copy nature line for line,
> Our end is lost. Not such the Master's care,
> Curious he culls the perfect from the fair;
> Judge of his art, thro' beauty's realm he flies,
> Selects, combines, improves, diversifies;
> With nimble step pursues the fleeting throng,
> And clasps each Venus as she glides along.[26]

Artists continued to produce scenes of rustic life through the eighteenth century, but from the second half of the seventeenth century the tendency in genre painting all over Europe was toward subjects of greater refinement and settings of a higher socio-economic level, and sometimes activities in exotic locales. History painters such as Boucher and van Loo did not hesitate to paint the mundane activities of the nobility and *haute bourgeoisie*, and even Chardin's austere interiors and plainly dressed figures are far from the coarseness of Jean Michelin's *Poultry Sellers*. Indecorousness was assiduously avoided, preternatural beauty abounded, and thus the artists, even in a minor genre, could follow the precepts of Du Fresnoy. Occasional attempts to incorporate a "lofty theme" in genre painting, usually of moralizing intent, became more frequent at the end of the eighteenth century, especially in the painting of Greuze, who hoped thereby to abolish the boundary between history and genre painting.

The most important innovation in genre painting in the eighteenth century was the introduction of the *fête galante*, which is, as Philip Conisbee points out, "a term impossible to translate, but refers to cabinet pictures with imaginary themes which show figures in costumes derived from the popular Italian comedy consorting in park-like settings."[27] The *fête galante* is genre painting at its most charming and idealized. Although there are clear precedents for the type, especially Rubens' various *Gardens of Love*, the innovation belongs to Watteau, whose work spawned several epigones and followers. Among the most talented of these, as well as the most independent from the example of Watteau, were Bonaventure de Bar (fig. 21), who died at a very young age, and Nicolas Lancret (figs. 33 and 34), whose work was collected across Europe by nobility and royalty, including Louis XV. Some *fêtes galantes*, such as Lancret's *The Captive Bird*, are vaguely anecdotal, and the viewer is invited to construct a story to suit the picture. Here a young man with a flute looks ostensibly at a bird in a cage, but his gaze actually goes through it to the real object—the pretty young woman holding the cage. The setting is pastoral, lush and verdant; the figures, in their splendidly colorful costumes, are relaxed and inclining toward each other; the symbolism of both the flute and the caged bird is erotic. The typically painterly brushwork—the legacy of the Rubénistes—adds a surface sensuousness to an intentionally charming and even seductive scene.

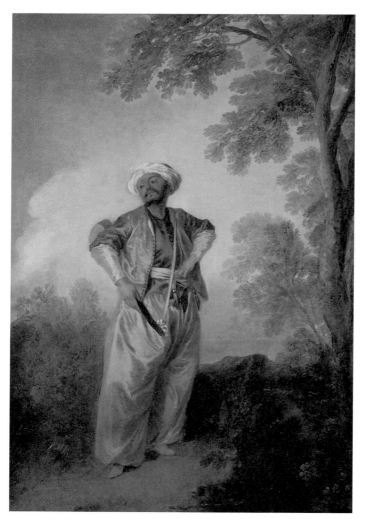

Fig. 34
Nicolas Lancret (1690 - 1743)
**The Amorous Turk (Le Turc amoureux)**, c. 1730-5
oil on canvas, (27-11/16 in. x 18-3/8 in.)
The Sarah Campbell Blaffer Foundation, Houston, Texas

## LANDSCAPE

French landscape painting, perhaps even more than history painting, owes its essence to Italy. In the course of the sixteenth century and definitively by the beginning of the seventeenth century, landscape gradually gained its independence from history as a subject for painting in Italy, following the tendency in Venetian painting to treat landscape as more than a mere backdrop to human action and with the input of northern artists in Italy, such as Paul Bril. Landscape painting in Italy never relinquished entirely signs of a human presence—there are always human figures and often domesticated animals—and, more often than not in the seventeenth century, the human activities depicted are the traditional historical subjects drawn from the Bible, religious and classical history, and mythology. Furthermore, in the typical "classical" or "ideal" landscape, nature is transformed, improved, in accordance with humanist art theory, that is, idealized just as much as human beings in figural works. The landscape is constructed as a coherent whole based on notions of classical and Renaissance composition. Exemplary ideal landscapes were created in the early seventeenth century by Italians such as Annibale Carracci and Domenichino, but the type reached its apogee later in the century in the work of two Frenchmen, Nicolas Poussin and Claude Lorrain, both ex-patriots who spent most of their careers in Rome.

Poussin, although primarily a history painter, began painting landscapes in earnest in the middle of his career, many of them for French patrons, and he brought to them the same sense of artistic and philosophical sobriety with which he painted his larger-scale figural compositions. Close to the landscape paintings of Poussin, but with a greater emphasis on architecture, is the work of Jean Lemaire, who was in Rome from at least 1624 (and possibly as early as 1613) until 1630, and again, briefly, in 1642. Nicknamed Lemaire-Poussin, he was a close friend of Poussin in Rome as well as his principal assistant during the latter's brief return to Paris. The mythological subject of *Mercury and Argus* (fig. 35) is derived from Ovid's *Metamorphoses*, the source of so many light-hearted and erotic Renaissance and Baroque paintings, but Lemaire presents the more placid and serious part of the story. Io, one of Jupiter's many female conquests, has been turned into a white heifer by his ever-jealous wife, Juno, who set the shepherd Argus to guard over her. Jupiter sent Mercury to kill Argus, which he does by first lulling him to sleep with the music of his

Fig. 35
Jean Lemaire, called Lemaire-Poussin (1597/8 - 1659)
***Mercury and Argus (Mercuse et Argus)***, 1650s
oil on canvas, (29 in. x 38 in.)
The Sarah Campbell Blaffer Foundation, Houston, Texas

pipes. The shepherd fatefully nods off against a fallen piece of column, his dog mirroring him from the other side of the painting, his goats grazing undisturbed. The composition, though weighted toward the right, is carefully balanced, and the uncluttered landscape extends in a clear and ordered progression from the stagelike foreground, consonant with the monumental architectural ruin at right. Lemaire specialized in architectural settings, known in the seventeenth century as *"perspectives"* (in Félibien's words, *"Il a fort bien fait les perspectives"*).[28] As much as the subject matter of the picture, this classical structure evinces the artist's interest in Roman antiquity. *Mercury and Argus* was, in fact, owned by Cassiano dal Pozzo—antiquarian, scientist, academician, familiar of the Barberini, and one of the most important private patrons of art in seventeenth-century Italy—who hung it between two landscapes by Poussin without architecture (now in the National Gallery, London), explaining in a letter to the Florentine collector Agnolo Galli that the combination of *"perspectives"* and landscapes, with the same figure scale, make a "most beautiful view."[29]

Claude's version of the ideal landscape, in which the effects of light are more pronounced, the compositions less crisply structured, and the (frequently but not exclusively historical) human activities less ponderous, enjoyed enormous success in his own time and remained a point of reference for landscape painters all over Europe, and even in America, well into the nineteenth century. Thus, in eighteenth-century France, Charles-François Lacroix de Marseille extended the play of light from a setting or rising sun across water as in Claude's numerous harbor scenes (and recalling also the coastal scenes of Claude's Italian contemporary Salvator Rosa). This effect is evident in *Italian Port Scene* (fig. 36), as well as in *Harbor and Boats*. Claude had often introduced nonhistorical figures into his works—shepherds, peasants,

Fig. 36
Charles François de la Croix de Marseille (d. 1782)
**An Italian Port Scene (Le Port italien)**, 1770
oil on canvas, (35-1/2 in. x 72 in.)
The Sarah Campbell Blaffer Foundation, Houston, Texas

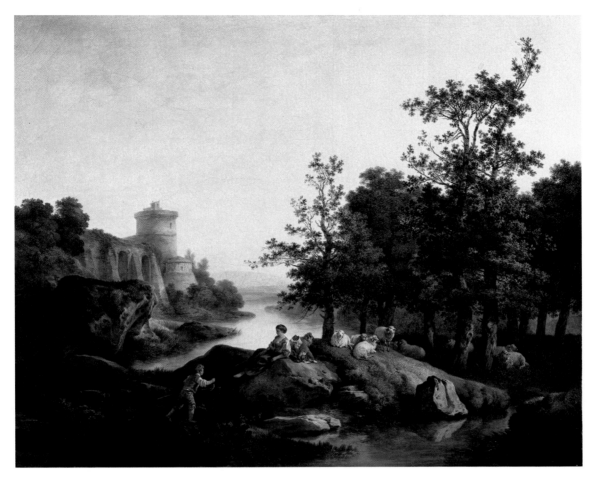

Fig. 37
Jean-Baptiste Huet (1745 - 1811)
***Landscape with Shepherds and Fishermen (Paysage avec bergers et pêcheurs),*** 1793
oil on canvas, (31-1/3 in. x 37-7/8 in.)
The Sarah Campbell Blaffer Foundation, Houston, Texas

merchants—rendering his paintings more picturesque if no less idealized, and, given the vogue for roman-ticized pastoral themes in the eighteenth century, paintings such as Jean-Baptiste Huet's *Landscape with Shepherdess and Boy Fishing* (fig 37), reminiscent of Claude's verdant settings and atmospheric effects, were popular.

## STILL LIFE

Still life, the depiction of things that are dead and motionless, in Félibien's pejorative phrase, was simultaneously at the bottom of the traditional hierarchy of genres and valued by every painter. In the French Academy, still life painters were usually disqualified from teaching, by reason of the putative

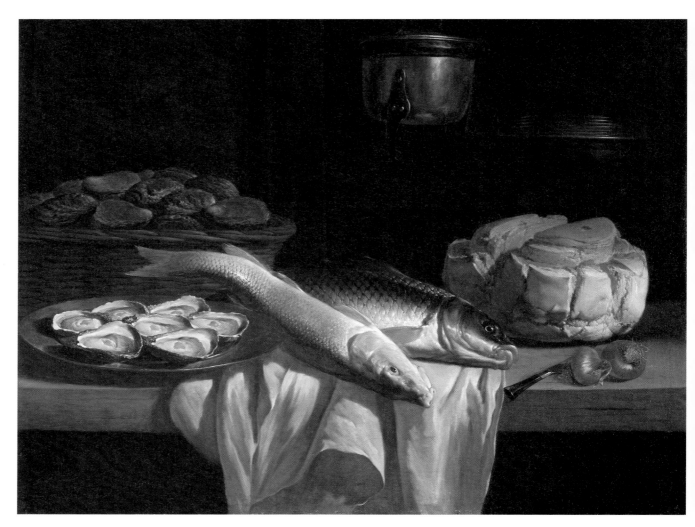

Fig. 38
Peter van Boucle (1600 - 1673)
**Still Life with Carp and Pike (Nature-Morte avec la carpe et le brochet)**, 1652
oil on canvas, (31-1/2 in. x 39-3/4 in.)
The Sarah Campbell Blaffer Foundation, Houston, Texas

insignificance of their art, but the drawing of still lifes was prized as a direct engagement with nature and the foundation of every student's training at the Academy.[30] Academic theory relegated still life to an exercise in manual dexterity and in the imitation of nature, necessary for every artist but not as ends in themselves. While still lifes required the same kinds of artistic choices necessary for any painting—composition, lighting, coloring, and so on—they were generally thought to be devoid of invention, that is, the artist's particular and imaginative portrayal of a subject, usually historical. Nonetheless, still life paintings were treasured by patrons—royal, noble, and bourgeois, including some history painters—and exhibited frequently and with little prejudice in the Academy (both as entries in the Salons and as *morceaux de réception*, which belonged to the Academy).

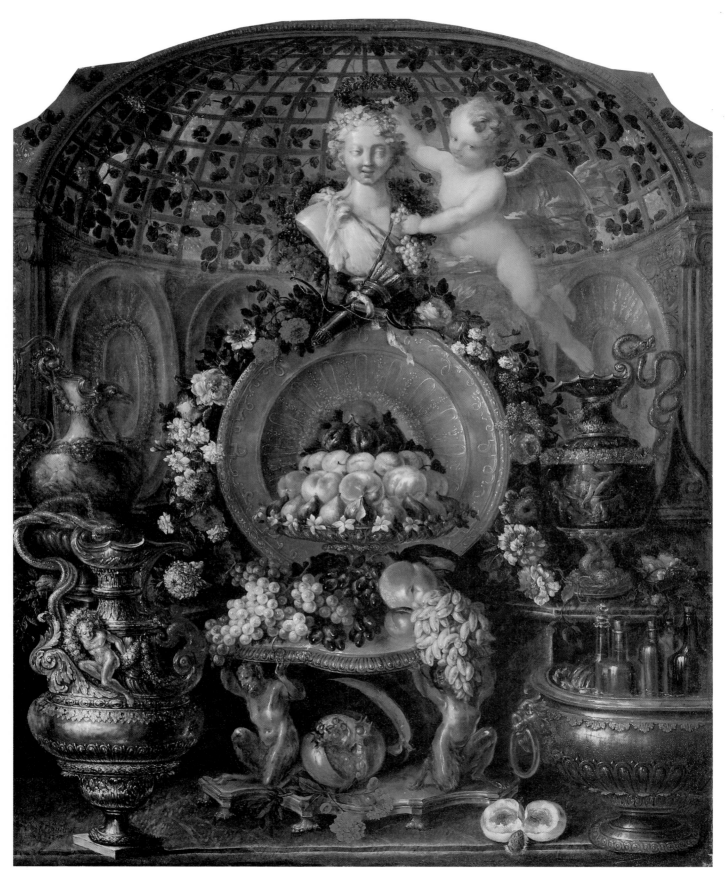

Fig. 39
Pierre-Nicolas Huillot (1674 - 1751)
**Still Life with Silver and Gold Vessels, Fruit and Flowers**
**(Nature-Morte avec les Vaisseaux d'or et d'argent, des fruits et des fleurs)**, 1718
oil on canvas, (105-1/2 in. x 86 in.)
The Sarah Campbell Blaffer Foundation, Houston, Texas

Like landscape and genre painting, still life was in the sixteenth century gradually liberated from history painting to form an independent genre. Although Italian artists were crucial to both the formation and development of still life painting in general, French still life received its greatest impetus from the Netherlands. From the beginning of the seventeenth century, numerous Netherlandish artists worked in France. Willem Kalf had a brief but important sojourn in France; others spent much of their working careers there, often gravitating toward each other in communities in Paris (especially around Saint-Germain-des-Prés), but fully entering the French artistic mainstream of Academy and court. Pierre Boucle (or Vanboucle, or Pieter van Bouckel, van Bouck, or van Boucken) was born and trained under Frans

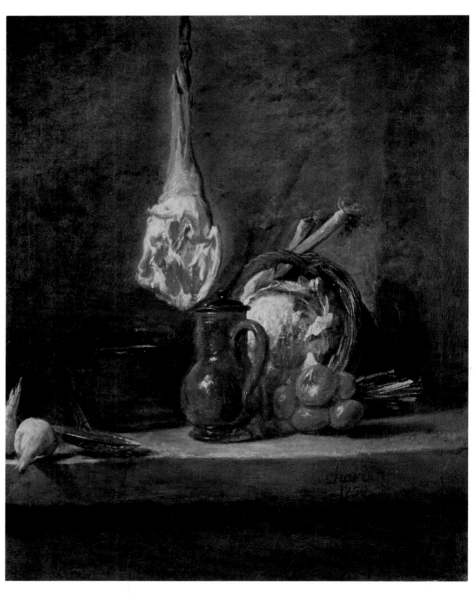

Fig. 40
Jean Baptiste Siméon Chardin (1699 - 1779)
**Still Life With Joint of Lamb (Nature-Morte avec agneau)**, 1730
oil on canvas, (15-3/4 in. x 12-3/4 in.)
The Sarah Campbell Blaffer Foundation, Houston, Texas

Snyders in Antwerp, but came to Paris in 1632 and worked there successfully (at least two of his paintings were in the royal collection, and he designed tapestries for the *Manufacture du faubourg Saint-Germain*). Owing to his personal debauchery, he lived in poverty, until his death some forty years later. Félibien praised him, saying he "painted animals perfectly."[31] His *Still Life with Carp and Pike* (fig. 38) represents a subgenre of still life—the banquet piece—in which Boucle specialized; as with other still life painters, the same kinds of objects recur in similar settings in a great many of his works. With its restrained composition of relatively few objects of rustic simplicity, it recalls examples from the Netherlands of the first half of the seventeenth century.

Just after the middle of the seventeenth century, still life painters in Paris abandoned intimate scenes of modest corners of reality for grandly fantastic and luxurious displays, as did artists elsewhere in Europe (especially the Netherlands). An extreme example is the huge *Still Life with Silver and Gold Vessels, Fruit, and Flowers* of 1718 (fig. 39) by Pierre-Nicolas Huilliot. A classicizing architectural arbor encloses a lavish display of *naturalia* and *artificialia*, presided over by a bust of a huntress (possibly Diana), crowned by a winged putto, cousin to Boucher's cherub harvesters. On a marble table top are piled, in symmetrically ordered profusion, elaborately ornamented gold and silver serving pieces, holding grapes, peaches, figs, and pomegranates and draped with variegated flowers to avoid any hint of restraint or sobriety. Jean-Baptiste Oudry's *Allegory of Europe* (fig. 22), though a still life of a very different sort, is equally fantastic and far removed from everyday experience, while meticulous in its details and convincing in its illusionism.

Jean-Siméon Chardin's *Still Life with Joint of Lamb* (fig. 40) heralds a modern approach to the representation of nature, yet it also harks back to an earlier aesthetic, sharing both the somber mood and the rustic elements of the paintings of Boucle and his generation (fig. 38). The humble kitchen utensils—a skimmer, a pot, a glazed covered pitcher, and a basket—and the turnips, leeks, onions, and cabbage are placed on a rough stone ledge, above which is suspended a leg of lamb. The indeterminate monochrome background, the strong lighting from the side, and the *trompe l'oeil* effect of the turnip perched on the edge of the table are inherited from the Caravaggism of the early seventeenth century, while the heavy impasto and painterly brushwork that elides details simultaneously recalls Rembrandt and looks forward to nineteenth-century realism in which the substance of tangible reality is conveyed by the material of paint itself. Chardin, the son of a carpenter, was received into the Academy in 1728 (remarkably, on the same day that he was *agréé*) "in the talent of animals" and fruits, and though he later took up genre subjects more frequently, beginning in the early 1730s until late in his career, he returned often throughout his career to depictions of a kitchen table with objects upon it, a dessert table, or dead game. An extraordinary sense of quietude, of undisturbed, silently observed reality, pervades all his works. Here, the stillness of the scene is underscored by the fact that though the leg of lamb is tightly composed with the other objects, it hangs utterly motionless from a hook whose support is not visible.

Still lifes, of course, were at the opposite end of the spectrum of genres from history painting, and Chardin's paintings of humble kitchen objects in particular did not have the ennobling features to recommend them to advocates of history, as did the paintings of Oudry and Huilliot, for example, with their allegorical trappings and princely displays of finery. Yet Chardin was widely patronized, and not just by what the collector Mariette disparagingly called *"le gros public."* Early on his genre scenes entered the French royal collections as well as those of Frederick the Great and the King of Sweden, and commissions for his still lifes late in his career included work for the royal châteaux of Bellevue and Choisy. Chardin was also highly respected by his professional peers, painters and critics (especially Diderot) alike. Following an exhibition of his work at the Academy in 1735, the *Mercure de France* commented appreciatively: "One

praises highly his knowing touch and the great truth that rules everywhere with an uncommon intelligence."[32] Chardin's fellow Academicians relied on him, as *tapissier*, to hang the pictures at the Salons. As much as anything else, Chardin's success—both in his own time and, since the mid-nineteenth century, in critical and art historical literature—demonstrates the flexibility of the Academy's hierarchy of genres, which recognized and fostered talented artists in each category.

Revolution in France brought with it substantial change to the practice of the arts, effected in particular by Jacques-Louis David, who was bent on destroying the Academy in which he had been trained but from which he had become disaffected for largely personal reasons. The demise of the Academy was heralded in the Salons of 1791 and 1793, which by law were now open to anyone, without respect to affiliation with the Academy (consequently, the number of paintings in them tripled). In 1793, the same year that David, as deputy to the National Convention, voted for the execution of Louis XVI, he addressed the Convention with vehemence and conviction on the state of the arts in France. He concluded: "In the name of humanity, in the name of justice, for the love of Art, and, above all through your love for youth, let us destroy, bring to nothing, the already too fateful academies which cannot any longer exist in a free state."[33] As a royal foundation and an institution premised on elitist principles, the Academy and the attitudes toward art it represented (including an institutionalized hierarchy of genres) could not have survived the Revolution without dramatic reworking. David's speech was an effective catalyst, and on that same day the Académie Royale de Peinture et de Sculpture—in his words "the last refuge of all aristocracies"[34] —was closed by law, marking a symbolic passing of the painting of the *ancien régime*.

## NOTES

*Thanks to Colin Bailey for his comments on a draft of this essay.*

1. In a letter to Paul Freart de Chantelou, translated by Marc Fumaroli, "Des leurres qui persuadent les yeux," in Pierre Rosenberg, *France in the Golden Age: Seventeenth-Century French Paintings in American Collections* (exh. cat.; New York: The Metropolitan Museum of Art, 1982), p. 3.

2. Andre Félibien, *L'Idée du peintre parfait* (London, 1707; rpt. Geneva, 1970), p. 85 (translations, unless otherwise indicated, are the author's).

3. Bellori, *Le vite de' pittori, scultori e architetti moderni*, edited by E. Borea (Turin, 1976), pp. 3–4.

4. Quoted by Pevsner, *Academies of Art Past and Present* (Cambridge, 1940; ed. New York: Da Capo, 1973), p. 99.

5. *France in the Golden Age*, p. 52.

6. The best brief account of the organization and history of the Academy remains Pevsner, *Academies of Art*, pp. 82–109, 177–179, and 198–200; for the early years, see also Antoine Schnapper, "The Debut of the Royal Academy of Painting and Sculpture," in June Hargrove, ed., *The French Academy: Classicism and Its Antagonists* (Newark: University of Delaware Press, 1990), pp. 27–36.

7. On the Salons, see Thomas E. Crow, *Painters and Public Life in Eighteenth-Century Paris* (New Haven, Conn.: Yale University Press, 1985.)

8. The most important exception in the second half of the seventeenth century was Pierre Mignard, who refused to join the Academy because of a personal rivalry with Le Brun. In the late eighteenth century Greuze, Fragonard, and David all operated outside the Academy or had problematic relations with it. See Thomas Gaehtgens, "The Tradition of Antiacademism in Eighteenth-Century French Art," in Hargrove, ed., *The French Academy*, pp. 206–218.

9. A. de Montaiglon, *Procès-verbaux de l'Académie Royale de Peinture et de Sculpture, 1646–1793* (10 vols.; Paris, 1875–1892), 4: 237.

10. Félibien, *Noms des peintres les plus célèbres et les plus connus anciens & modernes* (Paris, 1679;. rpt. Geneva, 1972), p. 58.

11. See Phillip Conisbee, *Painting in Eighteenth-Century France* (Ithaca, N.Y.: Cornell University Press, 1981), pp. 20–21.

12. Quoted by Michael Levy, *Painting and Sculpture in France 1700–1789* (New Haven, Conn.: Yale University Press, 1993), p. 46.

13. Félibien, *Noms*, p. 311; translated by George Shackelford, *Masterpieces of Baroque Painting from the Collection of The Sarah Campbell Blaffer Foundation* (exh. cat.; The Museum of Fine Arts, Houston, 1992), pp. 7–10. Félibien was republished in 1765. See also Pevsner, *Academies of Art*, p. 95.

14. Quoted and translated by Thomas Puttfarken, *Roger de Piles' Theory of Art* (New Haven: Conn.: Yale University Press, 1985), p. 127.

15. Du Fresnoy, *De Arte Graphica*, trans. William Mason as *The Art of Painting* (York, 1783; rpt. New York, 1969), p. 9 (vv. 100–105).

16. Quoted and translated from the *Mercure de France*, June 1735, by Alastair Laing in *François Boucher*, (exh. cat., Metropolitan Museum of Art, New York, 1986), p. 129.

17. Quoted and translated by Conisbee, *Painting in Eighteenth-Century France*, p. 91.

18. Anthony D. Smith, "The Historical Revival in Late 18th-Century England and France," *Art History*, 2, no. 2 (June 1979), 160.

19. Hal Opperman, *J. B. Oudry, 1686–1755* (exh. cat.; Galeries nationales du Grand Palais, Paris, 1982; Kimbell Art Museum, Fort Worth, 1983), pp. 73–74.

20. Smith, "The Historical Revival," p. 158.

21. Levey, *Painting and Sculpture*, p. 173.

22. On mythological subjects in eighteenth-century French painting in general, see Colin B. Bailey, *The Loves of the Gods: Mythological Painting from Watteau to David* (exh. cat., Kimbell Art Museum, Fort Worth, 1992).

23. Quoted and translated by Conisbee, *Painting in Eighteenth-Century France*, pp. 123–124.

24. Félibien, *Noms*, p. 61.

25. Du Fresnoy, *De Arte Graphica*, p. 5 (vv. 51–54).

26. Ibid., pp. 6–7 (vv. 64–79).

27. Conisbee, *Painting in Eighteenth-Century France*, p. 143.

28. Félibien, *Noms*, p. 69.

29. Donatella L. Sparti, "Criteri museografici nella collezione dal Pozzo alla luce di documentazione inedita," in F. Solinas, ed., *Cassiano dal Pozzo: Atti del Seminario Internazionale di Studi*, (Rome, 1989), p. 232 and fig. 8.

30. Charles Sterling, *Still Life Painting from Antiquity to the Twentieth Century*, (2nd ed., New York, 1981), p. 109.

31. Félibien, *Noms*, p. 69. See also Félibien's further comments quoted by Michel Faré, *La nature morte en France: Son histoire et son évolution du XVIIe au XXe siècle* (Geneva, 1962), I, 52.

32. Quoted by Levey, *Painting and Sculpture*, p. 206.

33. Quoted and translated by Jean-Pierre Mouilleseaux, "David: A Classical Painter against the Academy and Teacher of the French School." in Hargrove, ed., *The French Academy*, p. 131.

34. Ibid., p. 134.

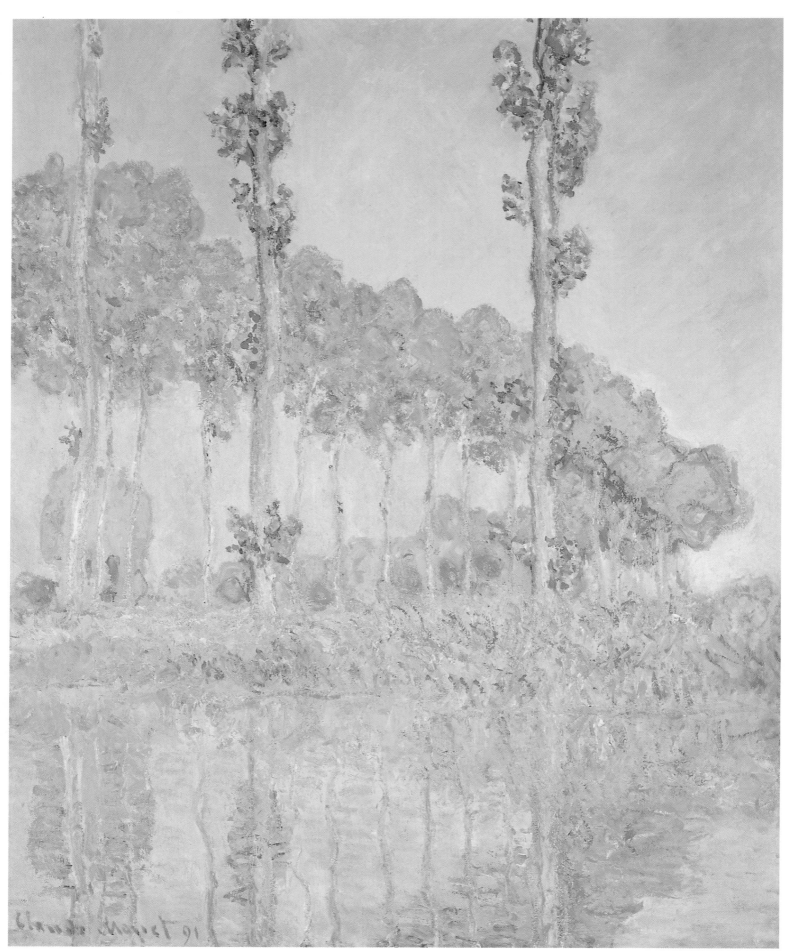

Fig. 41
Claude Monet (1840-1926)
***Poplars, Pink Effect (Les Peupliers, Effet du rose),*** 1891
oil on canvas, signed and dated lower left, *Claude Monet '91*  (42-1/2 in. x 29-3/8 in.)
Private Collection, Dallas, Texas

# The Landscape in French Painting, 1620–1920

**Richard R. Brettell**

It is impossible even to conceive of the history of French painting without landscape. Of France's greatest painters—Vouet, La Tour, Poussin, Claude, Le Brun, Watteau, Chardin, Boucher, Fragonard, David, Delacroix, Ingres, Corot, Courbet, (fig. 42) Manet, Monet, Renoir, Cézanne, Seurat, Gauguin, Matisse, Braque, Duchamp, and Leger—all but six made important contributions to the genre. And of the six— Vouet, La Tour, Le Brun, Chardin, David, and Ingres—the last two painted wonderful landscapes, either as settings (one thinks of Ingres's portrait of Mlle. Rivière) or, in rare but precious cases, as independent works. David's prison yard landscape is among the most chilling landscapes of protest in the history of art, and an exhibition of Roman views without Ingres's delightful tondo is unthinkable.

Surprisingly, no integrated history of French landscape painting has appeared since Lanoe and Brice produced their forgettable study in two volumes, published in 1901 and 1905 respectively. None of the great twentieth-century historians of French art has made a special study of landscape, and, perhaps most shocking, standard histories of French art usually de-emphasize it, even at its greatest moments. Ingres and Delacroix always overshadow Corot, Théodore Rousseau, and the Barbizon School in "larger" histories of French art, and, except for the shining decade of the 1870s, when the young Impressionists firmly made their mark in the arena of landscape painting, most of the very famous and "important" French paintings are figure paintings with either historical, allegorical, religious, or genre subjects. Every student of the history of art can think of one or two major figure paintings by Courbet, Manet, Seurat, and Gauguin, but few can conjure a specific landscape by Rousseau, Corot, Pissarro (fig. 45), or Sisley (fig. 43). Only in the cases of Cézanne (fig. 44) and Monet (fig. 41) does landscape finally become both memorable and central to the larger issues of French painting.

Fig. 42
Paul Gustave Courbet (1819 - 1877)
**Roe Deer at a Stream (Un Daim au ruisseau),** 1868
oil on canvas, signed and dated lower right *G. Courbet*, (38-3/8 in. x 51-1/8 in.)
Kimbell Art Museum, Fort Worth, Texas

The reasons for such neglect are beyond the scope of a short essay; indeed, it would require a book to excavate the collective psychology—and the politics—of this act of forgetting. Here, I want simply to assert again the obvious fact, that French painting and landscape painting are integrally related throughout their long histories. To any historian or reader of French literature this connection comes as no surprise. The very idea of *"la belle France,"* or just *"la France,"* has within it the notion of the national landscape. Even the French obsession with food tends to be rooted in landscape and regional agriculture. Eating a cheese or drinking a wine, tasting a sausage or savoring a stew, these all bring up immediate images of particular landscapes—landscapes that have been both visited and savored through literary and artistic representation. Even the memories that flow from Proust's famous taste of the *madeleine* are specific to a particular town near Chartres, in the great grain agriculture region of ancient Roman France.

In this exhibition, the visitor can experience that very interconnectedness through a series of paintings many of which would never be classified as landscape paintings, but most of which demonstrate their painter's study and knowledge of landscape form, of natural light, and of the particularities of certain places. Many of the seventeeth- and eighteenth-century figure paintings in the exhibition are "set" expertly in a landscape that lends credibility, atmosphere, and emotional resonance to the figural subject of the painting. Other paintings make clear that French landscapes as such survived well into the eighteenth century, a century associated so fervently with the *ancien régime* and its figural dramas

Fig. 43
Alfred Sisley (1839 - 1899)
***Bougival (Bougival),*** 1876
oil on canvas, (24-1/2 in. x 29 in.)
Cincinnati Art Museum, Cincinnati, Ohio
John J. Emery Fund

Fig. 44
Paul Cézanne (1839-1906)
***Rooftops (Les Toits),*** n.d.
oil on canvas, (25-7/8 in. x 32-1/8 in.)
Private Collection, Dallas, Texas

that one too easily forgets the then-famous landscapes of Claude-Joseph Vernet or the rise of illustrated travel books with their repertoire of landscape images derived from paintings. Indeed, the production of French landscape painters in both the seventeenth and eighteenth centuries surpassed in sustained achievement that of their only rivals, the Dutch, whose inventiveness in the genre failed to survive the seventeenth century, their Golden Age.

The history of landscape painting begins north of the Alps, but landscape makes definite and early appearances in the backgrounds of northern Italian paintings, particularly those from the Veneto. One cannot conceive of the history of landscape without Dürer, Altdorfer, or Joachim Patinir, nor Sassetta or Giovanni Bellini. Yet, for landscape painting as an independent genre filled with its own emotional resonance, one must wait until the seventeenth century, when it arose in both Holland and Italy simultaneously. Interestingly, the triumph of landscape painting in Italy was largely the responsibility of

Fig. 45
Camille Pissarro (1830 - 1903)
**Peasant Carrying Two Bales of Hay (Un Paysan portant deux bottes)**, 1883
oil on canvas, (27-7/8 in. x 23-5/8 in.)
Dallas Museum of Art
Gift of the Meadows Foundation, Inc.

foreigners, and the two greatest of these were French. Both Nicolas Poussin and Claude Lorrain spent virtually all their mature lives in Rome, making works of art for the international market in Italy. Their contributions to the genre contrasted much as would those of Cézanne and Monet in the nineteenth century, and the fact that Poussin and Lorrain each conceived of and executed landscapes in a different manner created a sort of schism within the genre that persists to this day.

Of the two, Poussin was the greater artist, not so much because of his technical skills, but because his ambitions far exceeded the modest aims of his compatriot. Whereas Poussin was a brilliantly educated, multilingual intellectual, Claude was an artist-worker or craftsman known for his supreme command of natural effects, particularly effects of light and atmosphere. Although he populated his landscapes with figures from history, mythology, and religion, no one has ever successfully demonstrated a deep affinity between Claude's landscapes and his figural subjects. Indeed, Claude was known primarily for beautiful, richly detailed, and spacious landscapes into which early viewers could project themselves with ease and pleasure. Meditating on a painting by Claude is literally an act of pictorial escape, so convincing are his mountains and valleys, so enticing his paths. Indeed, the world in Claude's paintings is always so much more extensive, so much greater than the actual visual world of a viewer, that an hour spent "within" a Claude Lorrain landscape can be considered almost equivalent to a journey through actual space and time. The limpid blue-green forest where Claude's Ascaneous shoots his stag evokes an entire age, a realm of nature that lies only in memory, but a realm made "real" by the painter.

The contrast with Poussin's landscapes could scarcely be greater. In most cases, Poussin's figural subjects play central roles in the conception of the landscape, forcing the viewer to analyze the paintings less as evocations of actual worlds than as ideal constructions where the balance of vegetation, architecture, geology, and weather is in accord with the meaning of the figural subject. In Poussin's *St. Matthew* in the Berlin Museum, or his *St. John* in the Art Institute of Chicago, the figures are the linch pin, the visual and intellectual key to the entire picture. Without them, the paintings would be static, devoid of the magic embodied in the minds of the apostolic beings. The landscape details in works by Poussin are conceived by the artist as "actualizing" devices, and the viewer believes in them as devices rather than as actual elements in nature. Not surprisingly, Poussin constructed his paintings, landscape and figural, using small doll-like models arranged in staged space, thereby working out pictorial problems of space, color, adjacencies, and scale in a theatrical manner. Claude, on the other hand, conceived of landscapes in sheerly pictorial ways, setting his figures in appropriate spatial niches or at the intersections of landscape planes, rather than conceiving of the entire landscape as an enlarged background for the figures. Often for Claude, light and season are as much the subject of the painting as are the figures, and his trees are often much more gloriously expressive than the figures arranged around them.

This contrast between Poussiniste landscape painters, who conceive of their craft in terms of human history and religion, and Claudian landscape painters, who evoke complete natural worlds into which significant figures are set, resounds throughout the history of landscape painting. Claude, in this situation, becomes a sort of naturalist or realist, while Poussin stands squarely on the side of idealism. But this contrast is false—untrue both to the history of landscape painting and to the particular cases of Poussin and Claude. *Both* artists construct artificial, natural realms based partly on pictorial formulae derived from the study of other works of art and, as a corollary to that, both artists studied nature in depth so that their works would have veracity as pictures. The difference between them lies in the nature of their "ideal" realms. For Claude, nature needed to be reconstructed into planes, ordered into studied curves, and arranged in a diagonally based spatial recession. These "idealizations" were done less for iconological reasons than because all artists must make pictures that are both varied and consistent so

Fig. 46
Jean-Baptiste-Camille Corot (1796 - 1875)
**The Mill and Three Cows. Contelea Road, Near Rouen**
**(Un Moulin et trois vaches. Route de Contelea, prés de Rouen)**, 1871
oil on canvas, signed lower right *Corot*, (19-1/4 in. x 23-1/4 in.)
Private Collection, San Antonio, Texas

as to be interpreted as art. Nature to Claude was an entire world that had to be transformed in order to become a landscape painting. For Poussin, the motivation for making paintings had little to do with nature and everything to do with important philosophical, religious, literary, and historical ideas.

Fortunately for the history of landscape painting, the contrast in approach was given a century to "cool down," and eighteenth-century French landscape painters spent their energies in less principled ways. Their masters can be divided into two camps. In the first were the painters of "real" life, who set a good many of their figural groupings in complex landscape settings. Watteau, Boucher, and Fragonard are the most important of these, and all three are essential to the subsequent history of French landscape painting: Corot and Monet are inconceivable without Watteau and Fragonard, and Renoir and Cézanne are inconceivable without Boucher. In the second camp were pure landscape painters, the towering giant of whom was Vernet. In a century in which landscape painting was ranked lowest in the hierarchy of genres approved by the venerated Académie des Beaux Arts, Vernet not only made a career of painting landscapes, but also earned the highest and most sincere praise from the greatest art critic of that century, Diderot. His range of subjects was greater than those of either Claude or Poussin. In the most dramatic terms, he was the first great French landscape painter who painted France. Although this act itself might not seem dramatic to us today, it was almost as significant as the style of his paintings or their various meanings. Vernet was a major artist who painted the actual countryside of his own nation and exhibited those paintings in official exhibitions alongside religious and history paintings. Although this feat had been accomplished a century earlier in Holland, the battleground was not as clear nor as dramatic. For France, painting was also about power and glory, and simple scenes of real countryside could not count in the struggle for pictorial glory that had been waged in France since the early seventeenth century.

Whether in the great series of the ports of France painted under the patronage of the king himself, or in the dramatic scenes of storms, avalanches, and mountains that terrified Diderot, Vernet expressed the entire range of human emotions in landscape painting. He did not resort to "important" figural subjects. In fact, most of his figures were called "staffage," of interest, that is, for their costumes, positions, scale, and authenticity rather than for their identity or meaning. Although he has not emerged in the twentieth century with a reputation even close to those of his Italian contemporaries Canaletto and Bernardo Bellotto, he played a much more critical role in the history of French painting than they did in Italian painting. Indeed, without his example and the ancillary work of his colleagues, students, and friends, the "revival" of landscape painting in France during the first third of the nineteenth century would simply never have occurred. To put it more boldly, without Vernet, the chance of Impressionism emerging would have been much less.

After Vernet, the artist who did more than any other to create the conditions for modern landscape painting was Pierre-Henri Valenciennes. His name scarcely elicits recognition today, but his importance for the history of modern art is as great as that of many artists with more prominent names. Valenciennes was an earnest and competent but secondary artist who, perhaps subconsciously realizing his liabilities as a painter, devoted a good deal of time to writing the first (and perhaps the last) great book on landscape painting published in French. Disguised as a treatise on perspective, it was actually an eight-hundred-page, carefully argued, and ambitious book that claimed for landscape painting an importance in the history of art that had once been reserved for religious and history painting. For Valenciennes, the landscape painter was the total artist, responsible for a knowledge of history and literature that rivaled Poussin's, as well as a knowledge of travel, geography, natural history, and botany that would have made Claude pale with envy. He created the conditions for the invention of a kind of landscape painting—called *paysage historique* or "historical landscape"—that combined Poussin and Claude

with the latest thinking about history and nature developed in France during the Enlightenment. Jean Jacques Rousseau and Diderot stand as firmly behind Valenciennes' ideas as do the Old Testament or Pausaneus.

The book, *Elements de perspective pratique*, appeared in 1800. By 1817 the Salon had begun to award a medal for landscape painting; by 1820 the books and paintings of several of Valenciennes' students had raised his arguments to a higher level; by 1824 a pure landscape painting by Constable was admitted to the Salon; and by 1830, a scant generation after Valenciennes' book appeared, the most revolutionary and important paintings at the Salon were not figure paintings but a group of landscapes painted by young French artists in their own country rather than in Italy. These rebels—Camille Corot and Théodore Rousseau, principally—changed the course of modern art. But they did so in a field that had been tilled for more than two centuries and in terms that had been set by earlier artists. Too often the early careers of Corot and Rousseau are equated to those of the young Impressionists in the sense of being spontaneous and without precedent. That view is as much a disservice to the national tradition of painting in France as it is to historical accuracy.

The central landscape painter in nineteenth-century France was Camille Corot (fig. 46). His earliest paintings and drawings from the 1820s stem from a tradition of natural transcription that had been codified by Valenciennes and his students. Yet, if one were to do an exhibition of the landscape oil sketches and drawings of French artists between 1770 and 1825, it would culminate with those of Corot. Perhaps because he was not inventing new technical and intellectual approaches to landscape, Corot was freer to push the limits of expression within the bounds of existing approaches. In this case, as in many others in the history of modern art, tradition was necessary for seemingly radical invention.

Between 1820 and his death in 1875, Corot was the dominating landscape painter in France. He brought landscape painting home to France but invested in the French landscape a rigor of structure and clarity of observation that had roots in Italy. He also walked the thin line between landscapes of fact (sheerly visual landscapes) and landscapes of structure (idealized landscapes). Most of his compositional techniques derive from the paintings of Claude Lorrain, who is the artist most important as a model for Corot. Yet his determination to embrace the modern landscape and the various regional landscapes of France does not stem from Claude's practice. Corot took on the mantle not only of Claude but also those of Watteau, of Vernet, and of Valenciennes. These became the mantle he wore throughout his life and left to Monet, probably without much enthusiasm. The extent and quality of his achievements as an artist are scarcely recognized today, in spite of the fact that his paintings are to be found in virtually every great museum throughout the world.

Corot's closest friend as a landscape painter, Théodore Rousseau, was the Dionysian equivalent to Corot's Apollonian example. Where Corot's landscapes are carefully constructed, ordered observations of nature, Rousseau's are either pictorial hymns to a pantheist vision or diabolical romances in which nature curses, screams, and weeps for the artist. One often thinks of meeting Ovid in Corot's landscapes—even when painted in France. Rousseau's, by contrast, would suit Shakespeare, Lord Byron, Victor Hugo, or even Mary Shelley. They seem settings for robberies or, at their best, for suicide. This emotional Romanticism is rare in French landscape painting, and, when it is done at the level of Rousseau, transcends in quality the landscapes of any other Romantic painters but Constable or Turner. In the career of Vernet, there are hints of Rousseau's nature, but only hints, and no painter between Rousseau and the late Cézanne again achieved this emotional resonance in the representation of landscape.

The next figure in the pantheon of French landscape painters was, like Poussin, not primarily a landscape painter. Known best as a painter of immense realist figure compositions, Gustave Courbet

Fig. 47
Paul Gustave Courbet (1819–1877)
**The Lake, near Saint-Point (Le Lac, environs de Saint-Point)**, 1872
oil on canvas, signed lower left *G. Courbet*, ( 19-1/4 in. x 23-1/8 in.)
Private Collection, San Antonio, Texas

nevertheless represented the landscape throughout his life (fig. 47). Focusing intently on the landscape near Ornans in eastern France, the region of his birth, he made mythic landscapes, mostly devoid of figures, that seem to act as embodiments of his own aspirations, desires, and frustrations. It was, in fact, the *"pays natale,"* ("landscape of birth"), that obsessed Courbet and that he embodied with a force and conviction that spoke clearly to a generation of Frenchmen, most of whom no longer lived in their native villages and towns, having migrated for financial reasons to the newly industrializing and capitalizing towns and cities of France.

Using "tools" like palette knives and scrapers as well as the more refined brushes of the traditional artist, Courbet literally worked to make powerful images of origin, source, and birth. His landscapes are at once real and purely mythological, allowing his viewers access into the mouths of dark caves, into the deep recesses beneath cliffs, into the clear, cool waters that spring from the earth itself. Courbet also painted the landscapes of French nationhood—the ravaged cliffs and beaches bordering La Manche,

Fig. 48
Claude Monet (1840–1926)
***Springtime in Giverny, Afternoon (Printemps à Giverny, effet d'après-midi)*** 1885
oil on canvas, (24 in. x 32 in.)
Museum of Fine Arts, St. Petersburg, St. Petersburg, Florida
Extended Anonymous Loan

where Frenchmen had boarded ships to conquer England in the eleventh century and where their descendants had looked with envy, and enmity, in the centuries since. The abandoned boats of the fishermen at Etratat were given painterly form by Courbet, a form that Monet was later to borrow—and exaggerate— at the end of the century. Courbet also created the iconic image of the pierced rock at Etretat, an image which seems, in his hands, to be a natural emblem of endurance and national strength. For him, landscape painting had no need of Italy, and, with Rousseau, he can be considered the first truly great landscape painter of France itself.

This brilliant and strong tradition—stronger than any landscape tradition in western art history— stands in back of the young Impressionists, who began their careers at the Salon exhibitions of the mid 1860s, standing on the shoulders of the giants whose careers they knew almost by heart. Like all young rebels, they repudiated the tradition to which they contributed, but without it, their art would not have been possible or certainly would not have been as strong. They also stood at the threshold of a period of intense technological and economic modernization in France, a period that was utterly to transform the actual relationships between Frenchmen and their landscape. Between the network of railroad lines and

the migration of a huge percentage of the French populace to cities, the cultural "sense of landscape"—indeed the cultural identity—was to shift so profoundly that represented landscapes had little choice but to shift in analogous ways.

In place of "fixed" landscapes denoting a stable history or a sense of life cycle, the Impressionists substituted unstable landscapes, filled with tourists and *promeneurs*, temporary inhabitants of beautiful places. The figures in their paintings will leave at the end of the day, of the week, or, if they are rich, of the season. Their moneys and cares lie in the cities of France, and the landscapes they preferred were places of escape and refreshment rather than places alive with history or places associated with their own families. This very sense of temporariness, of temporal instability, infuses the landscapes made by those young artists who banded together in 1874 to form a group that came shortly to be known as Impressionist. The name, though simplistic, like all names, is not really wrong, and for that reason it has persisted longer than their other early name, "the intransigents" (figs. 48, 49).

They rebelled, of course, but not against the world in which they lived (they understood that world perfectly) but against the world of artists who were so out-of-touch with modern social, economic, physical, and aesthetic realities. A new world needed a new art, but few artists recognized this as well as the Impressionists. They used everything they could from the arsenals of Courbet, of Rousseau, of Corot, and from the inspired, but less important careers of the Norman, Eugène Louis Boudin, and the expatriot Dutchman, Johann Barthold Jongkind. Yet, the most important lessons they learned were that painting had no fixed rules and that a landscape painting could be made at as high a level as any kind of painting. These simple lessons were to transform art. Within the relatively protected world of landscape painting—a world essentially unregulated by the Academy—their experiments could be carried on in a kind of freedom from false controversy that plagued the careers of figure painters like Manet, Courbet, and the young Cézanne.

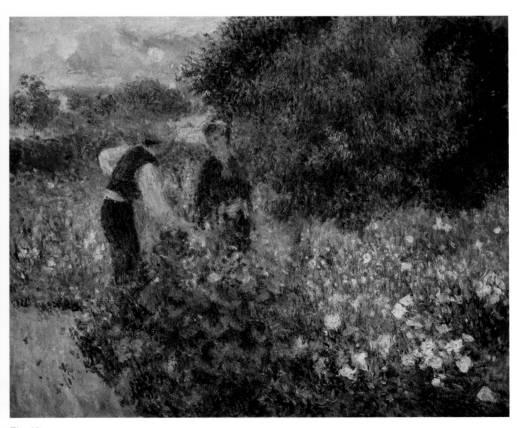

Fig. 49
Auguste Renoir (1841-1919)
**Picking Flowers (La Cueillaison des Fleurs)**, 1875
oil on linen, (21 3/8 in. x 25 5/8 in.)
National Gallery of Art, Washington
Ailsa Mellon Bruce Collection

Two visual phenomena that lie outside the restricted history of landscape painting affected its future utterly. One was the widespread use of photography as a mode of representing landscape and the other was the revival of etching in the 1860s. The first of these brought a new series of compositional strategies: higher horizon lines; bold, planar compositions; and visual compression in the middleground. The second encouraged artists to entrap landscapes with a series of short, discontinuous gestures that collectively give form to the landscape. Each of these technical advances went along with a new attitude toward the study of light and human perception of it. These attitudes were crystallized in a series of books and articles published in the 1850s and 1860s as the Impressionists began to develop their ideas of the modern landscape. The single most important idea in all this thinking and writing was the concept of reality as a vibrating "field of vision" perceived all at once by the eye and the brain, rather than as a collection of discreet, physical forms illuminated by the sun and analyzed separately by the eye. This optical or retinal idea of reality came to inform painting in a major way by 1868–69, creating a revolution in painted landscape representation that is still being interpreted to this day.

The field-of-vision concept presented a major problem to interpreters of landscape painting and to the painters themselves. If painters were representing this field of vision rather than variously meaningful forms in nature, what did it matter just what particular field of vision they chose to paint? Did painted views of a provincial town, a river scene, or an urban park have different meanings? Or, alternatively, were all these paintings equally meaningful as particular transcriptions of "vision" by a particular artist? The debate continues to this day.

All of modern art can be interpreted as a reaction to Impressionism. When considered in its fullest terms, Impressionism sowed the seeds that grew into the various forms of twentieth-century abstraction because Impressionist scenes are, when considered in the terms described above, only meaningful as painted transcriptions of "fields of vision." In this way, the particular forms in the paintings have no

Fig. 50
Jean-Baptiste-Armand Guillaumin (1841-1927)
**The River Oise at Auvers (L'Oise à Auvers)**, 1873
oil on canvas, signed lower left *Guillaumin*, (13 in. x 18 in.)
Private Collection, San Antonio, Texas

necessary significance in interpreting the painting. Impressionism can also be seen as the precursor of the various—and manifold—"anti-Impressionist" movements (Symbolism, Cubism, Synthetism, and so on) that sought to restore meaning to visual fields largely devoid of literary, religious, or historical associations. Whether modern artists valued the direct confrontation between painter and canvas as the arena of meaning in painting, as did the Impressionists, or, alternatively, whether they rebelled against this aesthetic by building up images slowly from a rich brew of earlier sources, the major French artists of the 1880s through the mid-twentieth century reacted to a set of visual ideas that the Impressionists inherited from the French tradition of landscape painting and that they codified in modern terms.

There is little doubt that the principal genre for modern French painting was landscape painting. Although modern artists have made major contributions to all the secular, bourgeois categories of representation—still life, portraiture, landscape, and genre—no one can doubt that landscape triumphed and that most of the major technical and aesthetic transformations of the idea of painting achieved by modern artists were first achieved in landscape. This exhibition gives San Antonio viewers their first opportunity to measure the entire history of French painting and to gauge within that history the strength of landscape representation as part of that history. Although several of the crucial artists are missing from this selection, the overall scope and range are remarkable. To learn about the French landscape, every Texan will have to come to San Antonio.

Fig. 51
Charles-François Daubigny (1817 - 1878)
**The Reapers (Les Faucheurs),** c. 1870
oil on canvas, (51-1/2 in. x 77-1/4 in.)
Private Collection, New York

Fig. 52
Edouard Vuillard (1868 - 1940)
**Mrs. Tristan Bernard (Madame Tristan Bernard),** 1914
oil on canvas, signed and dated lower left, (71 in. x 61-1/2 in.)
Private Collection, San Antonio, Texas

# *Impressionism:*
## REVISIONS, REVOLTS, SCHOOLS AND SCHISMS

## JOHN HUTTON

By the Eighth (and final) Impressionist Exhibition in May 1886, it was clear that the group was breaking into incompatible factions. From the outset, the Impressionists had been split along several fault lines: personal, political, and aesthetic. The history of the group from the first exhibition in 1874 was one of continuous quarrels, purges, and schisms. Only the pressure of major dealers, most notably Paul Durand-Ruel, led to the reluctant participation of several painters in the final show. (Ironically, commitments to Durand-Ruel's rival, Georges Petit, kept Claude Monet out of the same exhibition.)[1]

Those attending the 1886 exhibition might not have had any sense of the ongoing debates and feuds among the Impressionists. Few, however, could have missed the physical evidence of the debate, in the form of the paintings themselves. One room, dominated by Georges Seurat's *A Sunday Afternoon on the Isle of Grand Jatte* (1884–86), was entirely taken up by the self-proclaimed "scientific Impressionists" who gathered around Seurat. Of the established Impressionists, only one—Camille Pissarro—joined the new faction. That new alliance broke apart an older one, the so-called School of Pontoise, in which Pissarro had served as mentor and model for younger artists, including Paul Cézanne and Paul Gauguin. In marked contrast to Pissarro's new pointillist style, Gauguin's paintings followed, even exaggerated, the old style, being loosely painted in layered and overlapping greens and bright reds. Only one canvas—Gauguin's *Women Bathing* (1885)—hinted at new directions, with its quartet of oddly posed bathers in the midst of what the poet Paul Adam termed "an enormous metallic sea," undulating and rolling toward the viewers.[2] Most unexpected of all, in an exhibition put on by a movement dedicated to the celebration of light and air, must have been Odilon Redon's bleak charcoal sketch *The Secret* (1886), in which a tiny, gnomelike creature grasps the bars of a window and taps to be let in (or out).

The obvious gulf between the various exhibitors partially concealed one shared, if contested, vision: a retrospective understanding of what Impressionism had represented. The rather chaotic origins of the Impressionist current, the debates over its proper nature and scope, were largely glossed over retroactively in favor of a vision of Impressionism as a genuine movement, engaged in battle with artistic officialdom (in the form of the Academy and the annual Salon). The Impressionists were able, for a time, to incorporate in their movement the most disparate artists, exhibiting a variety of styles, from the anarchist Pissarro to the monarchist Degas, on a common platform of disdain for the Salon and those artists seen as too commercial, too interested in public acclaim and monetary reward.[3]

By 1886 that common ground had worn thin. The economic crises that began with the 1882 collapse of the *Union générale* bank and a rash of political scandals had squelched the burst of optimism and exuberance which had given birth to Impressionism. The Salon—always useful as an enemy—was in decline; it was disestablished from the state in 1880 and would break in two in 1889, with the secession that led to the rival *Salon de la National*. In 1884 it had faced its first sustained, institutional opposition, the *Salon des Indépendants* (Independents' Salon), set up as a democratic exhibition space, without juries, medals, or hierarchies.

In the artistic and political climate of the 1880s and 1890s an umbrella group like the Impressionists became impossible to sustain. The series of rival and would-be successor groups that began to form were, unlike the Impressionists, programmatic in nature, each with a relatively clear-cut and distinct style, and for most, that style was bound to a set of underlying beliefs about the world, about society, about religion or science. They codified not merely a way to paint, but a way to live and think. In a fractured and splintered era, the new catch phrase was "integral"—Integral Nationalism, Integral Catholicism, Integral Socialism—all promising a unifying worldview that would reintegrate society and establish social harmony.

Two opponents in particular claimed the mantle of successor to the Impressionists: the Neo-Impressionists (as the group around Seurat came to be called) and the "Impressionists and Synthetists" (later the Nabi Brotherhood), inspired by Gauguin. Both groups argued that the Impressionist emphasis on the fleeting moment led to superficiality; both called for an art of synthesis, which would simultaneously capture the real and the ideal, appearance and essence. Both sought to produce "integral" canvases, in which meaning was derived from the totality of line and color, without reference to traditional icons or allegorical figures. Both framed their aesthetic ideas in terms of broader social theories; both sought to capture an artistic and social harmony, as a contribution to realizing that harmony in the world around them.

The means by which the two groups sought those goals, however, were starkly opposed. Neo-Impressionists argued that the attempts on the part of the first "Romantic" Impressionists to depict the world around them were partial and intuitive, rather than precise and scientific. One could not simply stand in the midst of nature and capture it, as Monet sometimes asserted; rather, one had to study nature rigorously, to comprehend how light worked, how the mind interpreted form and color, and then meticulously shape a message based on those natural laws. The Neo-Impressionists did color wheel experiments to test scientific optical theories; they studied the texts of Charles Henry on the inherent meaning in lines, tones, and colors. Seurat wrote that "Art is harmony. Harmony is the analogy of contraries, the analogy of similarities, of tone, of tint, of line, examined in terms of a dominant and under the influence of a system of illumination in gay, calm, or sad combination."[4] For Paul Signac, who became leader and theoretician for the group after Seurat's sudden death in 1891, Neo-Impressionism sought "integral purity and complete harmony," as part of a quest for a "unified moral harmony" based on science and artistic tradition.[5]

By contrast, those who became the Nabis were distrustful of science and the modern technological world in general. Its theoreticians, especially Maurice Denis and Paul Sérusier, retreated from Paris to the rural Breton town of Pont-Aven (long a center for anti-Impressionist painters). Sérusier's *ABC of Painting* (1921) argued that art had gone off track in the late Renaissance, when technique and illusionistic tricks were emphasized—at the expense, he said, of genuine religious belief. Art had to return to its sacred roots, focused on timeless symbols. Both Denis and Sérusier saw their art as part of a revolt against a rootless and turbulent modern era, in favor of a return to the faith of the Middle Ages.[6]

The Neo-Impressionists retained the Impressionist palette of pure colors. In part to avoid mixed shades, they turned to dots (points) of color, intermingled in precise ratios. Focus was to be on complementary colors—red and green, violet and orange, for example—and their interaction. By contrast, the painters in Pont-Aven adopted a style which became known as cloisonnism: patches of flat color surrounded by heavy outlines, suggestive of cloisonné enamels. For Émile Bernard and Paul Gauguin, cloisonnism was useful as a means of suggesting a "primitive" naiveté, analogous to the stylized imagery of Byzantine religious art in the Middle Ages.

A major influence on the Nabis was Pierre Puvis de Chavannes (1824–98). *The Woodcutters* (fig. 53) typifies his work in form and subject: daily life and allegory are fused in a composition populated by still figures in sylvan glades. Puvis was honored by a broad spectrum of French society for his serenity and sense of timeless ease: Vincent Van Gogh hailed Puvis for his promise of a "rebirth of all things that one had believed in and desired," while even Jean Jaurés, the charismatic leader of the French Socialists, praised his painting for its repudiation of "the disorder of the times and the brutality of things."[7] *The Woodcutters* differs from Puvis's norm only in its relative complexity: the wide variety of brushstrokes, the relative sense of depth, and the sheer massiveness and corporeal quality of the central figures. In the main, Puvis's images are flatter, with a lighter palette, and figures who seem almost weightless. The Nabis sought to extend this flatness and deepen his colors, at the same time discarding the traditional roots of Puvis's images. Gauguin wrote that while Puvis would seek to depict "Purity" by "painting a young virgin with a lily in her hand—a well-known symbol, so everyone would understand," that concept could be better represented by painting a landscape which *embodied* the essence of purity: "a landscape with clear waters, without any stain from civilized man, perhaps without any people at all."[8]

The sharp contrast between the Nabis and Neo-Impressionists becomes apparent if we compare two works from the latter movement—Albert Dubois-Pillet's *Les Tours, Saint Sulpice* (fig. 54) and Maximilien Luce's *Le Louvre et le Pont du Carroussel, Effet du Nuit* (fig. 55)—with one from the Nabis, Paul Sérusier's *Landscape at Le Pouldu* (fig. 56). The two New-Impressionist canvases are wholly urban in their focus. Dubois-Pillet (1846–90) remains too little known today because of two tragedies: his sudden death of small-pox in 1890 and a subsequent fire which destroyed most of his paintings. *Les Tours, Saint Sulpice* hints at what a loss that was. A powerful, starkly linear work, the verticals of the church towers play off against the horizontals of the rooftops, structured around the two dominant colors, deep

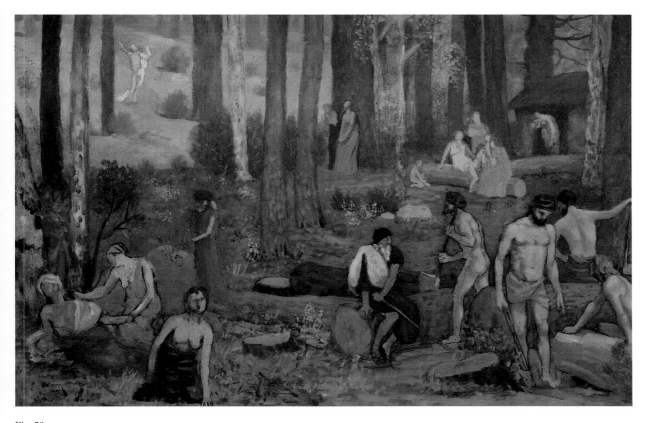

Fig. 53
Pierre Puvis de Chavannes (1824–1898)
**The Woodcutters (Les Bûcherons)**, 1871-1874
oil on paper, mounted on canvas, (29-1/2 in. x 45 in.)
Private Collection, San Antonio, Texas

purple and burnt orange. In accordance with Neo-Impressionist color theory, the complementary colors are set up as points of paint in precise ratios: the predominantly purple areas are mixed with scattered points of orange, while the ratio is reversed in adjoining areas of orange and umber.

In Dubois-Pillet's urban scenes, as in those of Seurat and Signac, there are seldom any people; the cityscapes are depopulated studies in line and color. By contrast, for Maximilien Luce (1858–1941), a product of the crowded working-class *faubourgs* of Paris, the city's entire significance as a modern urban center derived from its sense of crowded flux. The title of *Le Louvre et le Pont du Carroussel, Effet du Nuit* (1890) suggests the Impressionist canvases of Monet. Unlike Monet, however, Luce is not interested in capturing a transient moment. Rather, the scene is essentialized, the points of color fixing and delineating the cityscape in a manner wholly unlike the loose, layered brushwork and apparent spontaneity of Monet. Luce's love for urban light and color is evident. While his colleagues were beginning to explore the beauties of France's Côte d'Azur, Luce remained transfixed by Paris; his city night is calm and beautiful, the green and violet sky deepening to the dark purple at the horizon, that purple in turn contrasted to the brilliant lights and their reflections in the water.

Sérusier's *Landscape at Le Pouldu* (fig. 56), painted in 1890, the same year as Luce's work, clearly captures the difference between Nabis and Neo-Impressionists. The subject matter is rural, rather than urban—the tiny village of Le Pouldu, where Nabi artists retreated when even Pont Aven became too crowded. In place of the Neo-Impressionist granular, dotted surface, Sérusier's work is cloisonnist, composed of flat, outlined forms in patches of color which are juxtaposed without mingling. The small woman in the left foreground is in traditional Breton peasant garb—clothing which was actually disappearing in the real Brittany but which served the Nabis as perfect symbol of a traditional, premodern society, rooted in religious faith and connection to the land. Sérusier celebrates the natural life of the countryside in the flowing patterns and bright colors of the foliage. To the Nabis in Brittany, urban life was as unnatural as most nineteenth-century art. As with Puvis's art, Sérusier's painting is characteristically still. He insisted that any attempt to depict

Fig. 54
Albert Dubois-Pillet (1845–1890)
*The Towers of Saint Sulpice (Les Tours de Saint Sulpice)*, c. 1888
oil on canvas, (32 in. x 23-3/4 in.)
Private Collection, San Antonio, Texas

Fig. 55
Maximilien Luce (1858–1941)
**The Louvre and the Pont du Caroussel, At Night (Le Louvre et le Pont du Caroussel, Effet du Nuit)**, 1890
oil on canvas, signed and dated '90, (25 in. x 32 in.)
Private Collection, San Antonio, Texas

Fig. 56
Paul Sérusier (1863–1927)
**Landscape at Le Pouldu (Paysage à Le Pouldu)**, 1890
oil on canvas, (29-1/4 in. x 36-1/4 in.)
The Museum of Fine Arts, Houston
Gift of Alice C. Simkins in memory of Alice N. Hanszen

Fig. 57
Maximilien Luce (1858–1941)
***Factory Chimneys, Couillet near Charleroi (Les Cheminées d'usines, Couillet près de Charleroi)***, c. 1899
oil on canvas, signed and dated lower right, (29 in. x 39-1/3 in.)
Private Collection, San Antonio, Texas

motion was "a destruction of equilibrium; to represent movement is absurd." In paradise, the emphasis should be on stability and calm, not flux, and for Sérusier, the Breton peasants embodied some sense of the "paradisiacal days of primitive humanity."[9]

That Neo-Impressionist and Nabi canvases were shaped by the aesthetic and social doctrines of the two groups should not obscure the ways in which the individual artists worked with, revised, and sometimes ignored those doctrines as needed. In the wake of the Impressionists, new artistic movements provided artists with a context, a body of supporting theory, and a group of active collaborators. Those factors in turn were shaped by the general social, political, and economic climate and by issues of patronage and (increasingly) the art market. The paths by which artists *negotiated* the choices imposed by these interacting forces were their own. In an era of competing artistic circles, some artists were attracted to a group primarily by its politics (or worldview generally), others by its artistic theories. The ultimate trajectories of artists in such movements can be quite different. Perhaps more importantly, once the art of the competing groups was on public display, it became part of an ongoing visual debate, in which new artists, unaffiliated with any of the rivals, appropriated whatever they liked, transforming their art often in quite unexpected ways.

That process of differentiation was already apparent in the canvases by Luce and Sérusier. Unlike Dubois-Pillet, who made a rigorous study of optical theory, Luce's application of pointillist technique was

far more intuitive and personal. Luce sometimes complained that Neo-Impressionist theory was too confining, that it ruled out instinct.[10]

Nor could Neo-Impressionist theory—or the whole body of anarchist social theory with which it quickly became fused—provide an answer to specific issues of how to capture, in one still image, an essential meaning for a scene or theme, particularly when the theories provided contradictory answers. For Luce, that became especially apparent when he was invited in 1895 to tour the so-called Black Country, the mining region of Belgium. Luce identified with the workers of the region; many of his pictures show laborers and steelworkers as assertive and confidant. The impact of what he saw in Belgium, however, was difficult for him to assimilate. Luce's anarchist mentors hailed the growth of technology, science, and urbanization as proof of human advancement; at the same time, they decried the misery, squalor, and brutality that accompanied such growth. Luce wrote to a colleague in 1895 that "It is [at

Fig. 58
Maximilien Luce (1858 - 1941)
***Portrait of the Artist Charles Angrand***
***(Portrait du peintre Charles Angrand)***, 1908
oil on canvas, signed lower left, (28 in. x 23-1/2 in.)
Private Collection, San Antonio, Texas

once] so terrible and so beautiful that I doubt it can be rendered as I want."[11] That ambivalence finds clear expression in his *Factory at Couillet* (fig. 57), painted three years later. The canvas depicts a factory town, in which nature and industry do not so much coexist as stand juxtaposed to one another. The strangely beautiful, violet factory is contained by surrounding green hills and by the line of row houses, which is itself juxtaposed to greenbelts. Industrial desolation and greenery are counterposed. The painting can be dissected as a series of diagonals and walled-off zones. Ironically, the dots of color interact in the painting, but not the factory and vegetation, which flourish simultaneously, each in its proper sphere.

Ultimately, Luce came to reject Neo-Impressionist technique and theory in favor of a realism influenced by the work of Honoré Daumier. Luce's 1908 portrait of his friend and colleague Charles Angrand (fig. 58) demonstrates that shift; there is no trace of the dotted color of his canvases from the 1890s. Luce always valued message and emotional impact over theory. Here, Luce gives us an empathic image of a close friend.

Luce came to abandon Neo-Impressionist technique; others played with it for new ends. During the 1890s, artists as diverse as Henri Matisse and the Nabi artists Maurice Denis and Pierre Bonnard experimented briefly with pointillism. Among them was the young Jean Metzinger (1883–1956), better known for his Cubist works in the twentieth century. Metzinger's scientific education drew him to the Neo-Impressionist interest in optical theory, and he experimented with the technique from 1905–09. In his *Pointillist Landscape* (fig. 59), as is common among these late adaptations of Neo-Impressionism, the points of color have become enlarged; they resemble colored confetti, producing an effect not unlike a mosaic. There is no pretense at a scientific selection of colors. The painting builds upon a contrast

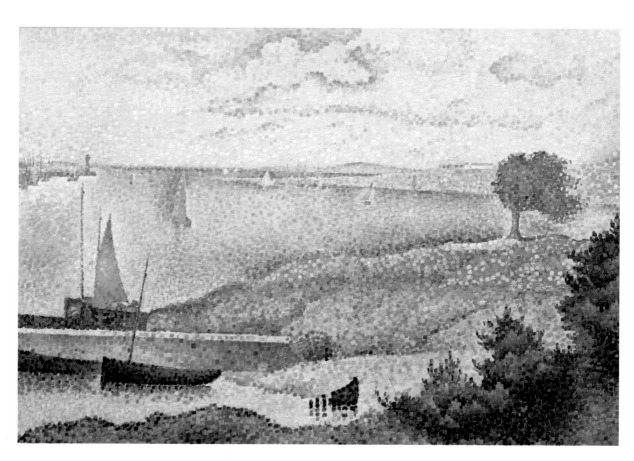

Fig. 59
Jean Metzinger (1883–1957)
***Pointillist Landscape (Paysage Pointilliste)***, 1906-1907
oil on canvas, signed lower right, (25-3/4 in. x 35-1/4 in.)
Private Collection, San Antonio, Texas

Fig. 60
Lucie Coustourier (1870 –1925)
***Woman Dozing (Femme assoupie)***, c. 1900
oil on canvas, signed lower center, (31-1/2 in. x 26-1/2 in.)
Private Collection, San Antonio, Texas

between dominant purples and blues (in the shadows and cloudy sky) and a range of greens. Metzinger was not alone in finding the starkness of such a contrast unsettling; the solution was to use a range of intermediate shades (termed *passage*) to soften, almost to buffer, the collision of contrasting colors. Here, he uses the yellows, soft greens, and whites of the shore.

Lucie Coustourier (1876–1925) was a student of Paul Signac. Best known today for her biographies of Séurat and Signac, Coustourier's own paintings are immediately recognizable for her free adaptation of Neo-Impressionist technique. Like Metzinger, Coustourier has enlarged the points of paint in her *Femme assoupie (Woman Dozing)* (fig. 60) to create a mosaic effect. With Coustourier, the colors no longer form a solid mass of points but cluster around the contours of the woman sleeping before her easel, leaving much of the surface of the painting open. The emphasis is on curving contours, rhythmically defined by the rows of colored points, echoing and reinforcing one another. (For example, the figure is outlined by a series of dark blue points of color; within those is a second series, in purple, then a third in lighter blues and violets, then the white canvas.)[12]

Similar developments occurred within and around the Nabi circle. Even Sérusier's painting blended cloisonnist ideas with more traditional representational systems. Unlike the Breton pictures of Bernard and Gauguin, for example, the green patches representing the forest are not flat, empty patches of color. Sérusier sketches in blades of grass and some hints of foliage to make the scene more legible to a viewer. Some within or on the fringes of the Nabi circle came to reject the whole cloissonist style. There was always a tension in the group between the idea, inherited from the Impressionists, of working

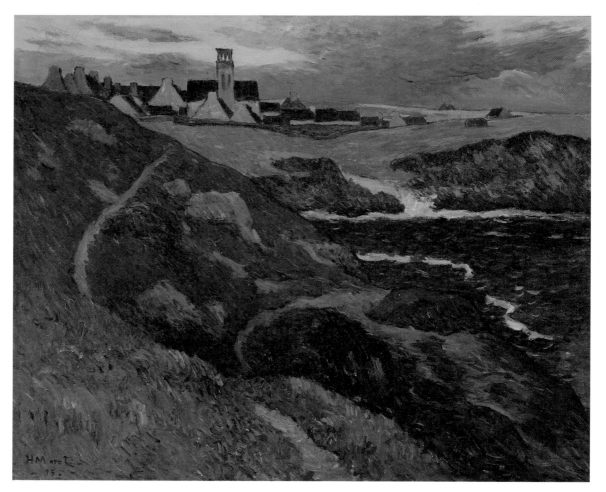

Fig. 61
Henri Moret (1856–1913)
**The Village of Lampaul, Isle of Ouessant (Le Village de Lampaul, Isle d'Ouessant)**, 1895
oil on canvas, signed and dated lower left '95, (28-3/4 in. x 23-3/4 in.)
Private Collection, San Antonio, Texas

from the colors visible in the landscape before the artist, and the contrasting notion that a painting is a personal vision, to be structured and styled in whatever way the artist chooses. For Henri Moret (1856–1913), the solution was to blend the two styles, as in his *Le Village de Lampaul à Quessant* (fig. 61). The basic outlines of a Nabi landscape (in particular, the division of the canvas into large patches of flat color) are clearly apparent, but they are covered with stylistic flourishes tied to Impressionism—a loosely painted surface and broad, overlapping strokes.[13]

Georges Lacombe (1868–1916) finds a different balance. His *Le Bûcheron et la femme (The Woodcutter and the Woman)* (fig. 62) shares with earlier Nabi works the focus on rural life as a kind of morality tale about the relationship of humanity to labor in the natural world: a woman gives food to a woodcutter, who mops his brow after chopping down a tree. That Biblical theme (the injunction to Adam

Fig. 62
George Lacombe (1868–1916)
**The Woodcutter and the Woman (Le Bûcheron et la femme)**, 1896
oil on canvas (45-1/4 in. x 63-3/4 in.)
Private Collection, San Antonio, Texas

and Eve to earn their bread by the sweat of their brow) is expressed in a painting that draws at will from the Nabis and the Neo-Impressionists. Lacombe's brushstrokes vary enormously over the canvas; in the cut wood, they form interlocking bricklike shapes. The goal is not consistency but effect, a continuing drive to create dramatic color relationships.[14]

Émile Bernard (1868–1941) was the central figure both in establishing the (ex-)Impressionist colony in Pont Aven and in formulating the cloisonnist style. He quarreled with Gauguin over who should take precedence in the new movement, however, and never joined the Nabis. His 1891 *Two Bathers* (fig. 63) illustrates his search for a distinctive style, indebted (in varying degrees) to Puvis, the Nabis, and the Impressionists. The range of that experimentation can be seen if we compare it to his portrait of Georges Lacombe from three years earlier (fig. 64). The portrait of Lacombe demonstrates his early interest in simplifying forms—the heavy brows, the symmetrical beard, and the straight lips. The colors, as in his cloisonnist paintings, are largely self-contained, but they do interact in localized areas (for example, the traces of blue pigment in the brown hair). In *Two Bathers*, the painting is less unified in

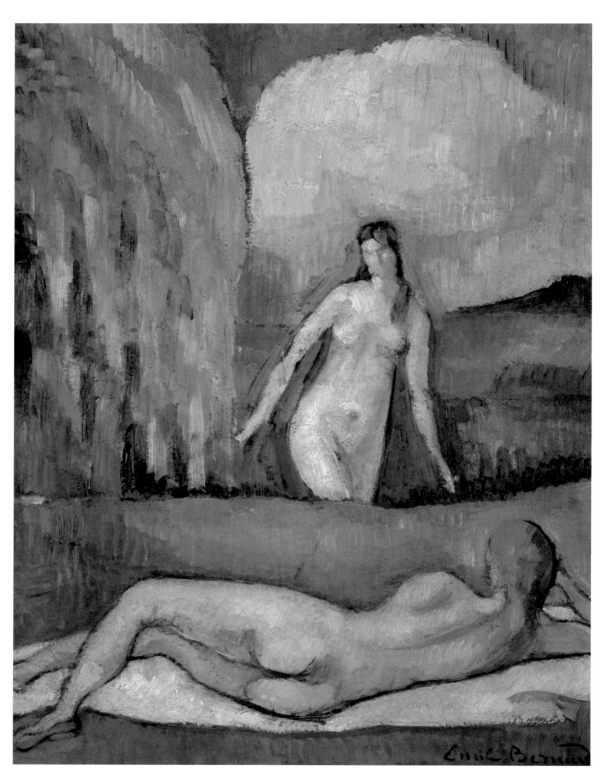

Fig. 63
Emile Bernard (1868–1941)
**Study of Two Bathers under a Willow Tree (*Étude de nus sous un saule*)**, 1891
oil on panel, signed lower right and dated '91, (18-1/2 in. x 14-1/2 in.)
Private Collection, San Antonio, Texas

Fig. 64
Emile Bernard (1868–1941)
***Portrait of Nabi Sculptor Georges Lacombe (Portrait du sculpteur Nabi Georges Lacombe)***, 1888
oil on canvas, signed and dated lower right 1888, (16-1/4 in. x 13 in.)
Private Collection, San Antonio, Texas

that the brush strokes and color vary from area to area. The standing nude is heavily outlined, and the flatness of the figure is counteracted in part by varied skin tones. The cloud above her is partly transparent, with layered colors, as is the tree. The grass is textured. Certain areas of the canvas are flat and opaque; in others colors interpenetrate at will. As with the Lacombe painting, the goal is not consistency on a theoretical basis, but variation on a personalized, intuitive basis.

From the outset, the Nabis were divided between their rural (Breton) and urban wings. The urban Nabis—most notably Pierre Bonnard and Édouard Vuillard—shared the comfortable background of the Pont Aven painters and were educated at the same art schools (especially the Académie Julien in Paris). Both wings were influenced by Gauguin and Puvis. The urban Nabis were never comfortable with

the mystical, sacramental focus in the art and theories of Sérusier and Denis, however. Increasingly, the art of Bonnard and Vuillard came to focus on intimate scenes of daily life in the interiors of middle-class households. In these *intimite* paintings, the Nabi emphasis on zones of heavily outlined color is modified into a fascination with juxtaposed colors, patterns, and even textures. Vuillard's *Portrait of Mme. Tristan Bernard* (fig. 52) exemplifies those interests. The subject rests comfortably on a couch in her drawing room, petting her dog. The canvas surrounds her with contrasting zones of bright color: the pale creams and greens at the upper right, the patterned lavender and green of the wallpaper, the yellows and greens of the flowers at lower left. The contrast is not simply one of zones of color, but also of patterns: Mme. Bernard's black and brown clothing is contrasted to the blue and yellow stripes of the sofa, the

Fig. 65
Othon Friesz (1878 - 1949)
*Cassis (Cassis)*, 1907
oil on canvas, signed lower right and dated '07, (21-1/4 in. x 25-1/4 in.)
Private Collection, San Antonio, Texas

embroidered lace behind her, even the shaggy hair of her pet. The dramatic contrasts of color and pattern are reinforced by Vuillard's play with textures: he routinely varied these in his oil paintings, painting sections in distemper, which creates a flat, chalky surface, and *peinture à la collé,* involving glue mixed with colored powders.

By the early twentieth century, debates between the Nabis, the Neo-Impressionists, and their rivals had become meaningless. As far as younger artists were concerned, they had taken their place with Impressionism as archival sources—part of the past, to be mined for effects and techniques as needed. Artists such as Matisse had typically spent their early careers experimenting with each in turn, before moving onto new ground. Some (such as Rouault) were as deeply religious as the Nabis; others (such as Vlaminck and Picasso) shared the anarchism of the Neo-Impressionists. These beliefs were no longer expected to tie an artist to a specific school or movement, however, and new coalitions and groupings were forming, based on new issues and new debates.

The Fauves (literally, the "Wild Beasts") got their name at the 1905 exhibition of the new *Salon d'Automne*, set up to bridge the gap between the stodgy official Salons and the radical *Salon des Indépendants*. One critic dismissed the Fauve paintings (grouped together in a single room at the Salon d'Automne) as "Formless streaks of blue, red, yellow and green, all mixed up, splashes of raw color juxtaposed without rhyme or reason, the naïf and brutal efforts of a child playing with its paint box."[15] The tone is vituperative, but the critic identified precisely what the new art offered: what the Fauve André Derain termed "color for color's sake," coupled with a Nabi-like emphasis on simplified forms. Form was to be expressed not by drawing or shading, but through the direct juxtaposition of colors, applied with a free verve totally alien to the Neo-Impressionists and Nabis alike.[16]

Othon Friesz's *Cassis* (fig. 65) and Georges Braque's *L'Estaque* (fig. 66) help to define the new movement, and to indicate why contemporaries found their works so jolting. Friesz wrote that Fauve paintings were intended to be visionary: "We perceived that a picture could not be constructed without first transforming our ordinary, direct, and mediocre vision of reality" through the free play of colors. Both works are in clear contrast to earlier movements—but just as clearly grow out of the individual experiments and styles developed by the artists trained in those movements. The painting by Braque, done in 1906, shortly before his interest in Cézanne would lead him toward Cubism, is noteworthy for its brilliant reds, yellows, and greens, for the varied brushwork, and for the way in which color itself defines the forms.[17]

The notion of a single system, a single set of rules for painting had already died by the time the Impressionists took shape. The break-up of the Salon as the site where paintings had to be shown to be taken seriously and the rise of a network of rival private dealers struck the final blow to any idea of painting as a common discourse, with shared concepts, subjects, and a permissible range of styles. The world of painting became as fragmented, as transitory, as the modern world itself. In such a climate, two pressures are constantly at war with one another: a continual drive to produce something new and innovative, a drive connected to the fluctuating moods and rhythms of the society as a whole, countered by a strong desire to fix and define the world, to reestablish some sense of permanence and intelligibility. Artistic movements have emerged in response to both pressures, while individual artists have sought to negotiate their way through the multitude of contradictory claims and goals of each. No artistic answer is permanent, any more than its underlying understanding of the world goes unchallenged. What remains is the constant effort to understand and interpret the world—and the legacy of the powerful works of art which bear ongoing witness to the intensity of that struggle.

Fig. 66
Georges Braque (1882 – 1963)
**Landscape at L'Estaque (Paysage à L'Estaque)**, 1906
oil on canvas, (20 in. x 23-3/4 in.)
New Orleans Museum of Art, New Orleans, Louisiana
Bequest of Victor K. Kiam

## NOTES

*Special thanks to Aurora Molina for her help in preparing this essay.*

1. Both debates and schisms can be traced in Charles Moffett, ed., *The New Painting: Impressionism, 1874–1886* (San Francisco: Fine Arts Museums of San Francisco, 1986). For the final show, see especially the essay by Martha Ward, "The Rhetoric of Independence and Innovation," pp. 421–473.

2. Moffett, ed., *The New Painting*, p. 458.

3. For the idea of the "free" artist, independent of Salon or commercial dealer, see Ward, "The Rhetoric." The roots of that idea are discussed in more detail in Robert Jensen, *Marketing Modernism in Fin-de-Siècle Europe* (Princeton: Princeton University Press, 1994), pp. 81–106.

4. See Richard Thompson, *Seurat* (Oxford: Phaidon Press, 1985), pp. 225–226. For Neo-Impressionist artistic theory, see especially Michael Zimmerman, *Seurat and the Art Theory of His Time* (Antwerp: Fonds Mercator, 1991), pp. 227–278, and Floyd Ratliff, *Paul Signac and Color in Neo-Impressionism* (New York: Rockefeller University Press, 1992), pp. 33–192, on Signac's color theories.

5. Signac, *D'Eugène Delacroix au néo-impressionism* (Paris: Herman, 1978), pp. 104–105; see also John Hutton, *Neo-Impressionism and the Search for Solid Ground: Art, Science, and Anarchism in Fin-de-siècle France* (Baton Rouge: Louisiana State University Press, 1994) pp. 28–45.

6. See Sérusier, *L'ABC de la peinture* (1921; reprint Paris: Librairie Flouy, 1950); for Sérusier's artistic theories, see also Caroline Boyle-Turner, *Paul Sérusier* (Ann Arbor: UMI Research Press, 1983), especially pp. 111–168. For an excerpted English translation of Denis's theories, see his "From Gauguin and Van Gogh to Classicism," in *Modern Art and Modernism*, ed. Francis Frascina and Charles Harrison (New York: Harper and Row, 1983), pp. 51–55.

7. Hutton, *Neo-Impressionism*, pp. 119–121.

8. Robert Delevoy, *Symbolists and Symbolism* (New York: Rizzoli, 1982), p. 161.

9. See Boyle-Turner, *Sérusier*, pp. 64, 116.

10. Phillipe Cazeau, *Maximilien Luce* (Lausanne, Paris: La Bibliotheque des arts), p. 105.

11. See Hutton, *Neo-Impressionism*, pp. 173–177.

12. The literature on Coustourier is still very scanty; see Ellen Wardwell Lee, *The Aura of Neo-Impressionism: The W. J. Holliday Collection* (Indianapolis: Indianapolis Museum of Art, 1983), pp. 92–93 and William E. Steadman, *Homage to Seurat: Paintings, Watercolors and Drawings by the Followers of Seurat* (Tucson: University of Arizona Art Museum, 1968).

13. For Moret, see Judy Le Paul, *Gauguin and the Impressionists at Pont-Aven* (New York: Abbeville Press, 1987), pp. 197–209; Wladyslawa Jaworska, *Gauguin and the Pont-Aven School*, trans. Patrick Evans (Greenwich, Conn.: New York Graphic Society, 1972), pp. 181–186.

14. For Lacombe, see Le Paul, *Gauguin*, pp. 225–233.

15. Jean-Paul Crespelle, *The Fauves*, trans. Anita Brookner (Greenwich, Conn.: New York Graphic Society, 1962), p. 14; John Russell, *The World of Matisse, 1869–1954* (New York: Time-Life Books, 1960), p. 52.

16. Crespelle, *The Fauves*, p. 4.

17. A comparison might be made to a style first set out by the Nabis but abandoned as their work became more defined: see, for example, Sérusier's *The Talisman* of 1888 and Denis's *Splashes of Sunlight on a Terrace*, 1890. The apparent formlessness of these early Nabi works led to their growing insistence on tightly defined form; a similar uneasiness would lead Friesz back to a more academic style, and Braque to the rigors of analytical cubism.

# *Selected Bibliography*

BAILEY, COLIN B. — *The Loves of the Gods: Mythological Painting from Watteau to David.* Exh. cat. Kimbell Art Museum, Fort Worth, 1992.

BELLORI, GIOVAN PIETRO. — *Le vite deí pittori, scultori e architetti moderni.* Ed. E. Borea. Turin, 1976.

BOYLE-TURN, CAROLINE. — *Paul Sérusier.* Ann Arbor: UMI Research Press, 1983.

CAZEAU, PHILIPPE. — *Maximilien Luce.* Lausanne, Paris: La Bibliotheque des arts, 1982.

CHASSE, CHARLES. — *The Nabis and Their Period.* Trans. Michael Bullock. New York: Praeger, 1969.

CLARK, T. J. — *The Paintings of Modern Life: Paris in the Art of Manet and His Followers.* New York: Knopf, 1985.

CONISBEE, PHILIP. — *Painting in Eighteenth-Century France.* Ithaca, N.Y.: Cornell University Press, 1981.

CRESPELLE. — *The Fauves.* Trans. Anita Brookner. Greenwich, Conn.: New York Graphic Society, 1962.

CROW, THOMAS E. — *Painters and Public Life in Eighteenth-Century Paris.* New Haven, Conn.: Yale University Press, 1985.

——————. — *A Day in the Country: Impressionism and the French Landscape.* Los Angeles County Museum of Art, 1984.

DU FRESNOY, CHARLES ALPHONSE. — *De Arte Graphica.* Trans. William Mason as *The Art of Painting.* York, 1783; rpt. New York, 1969.

FARÉ, MICHEL. — *La nature morte en France: Son histoire et son évolution du XVIIe au XXe siécle.* 2 vols. Geneva, 1962.

FÉLIBIEN, ANDRÉ. — *Conférences de l'Académie Royale de Peinture et de Sculpture.* Paris, 1669. Collected in his *Entretiens sur les vies et sur les ouvrages des plus excellents peintres anciens et modernes.* 6 vols. Trévoux, 1725; rpt. Farnborough (Hants), 1967.

——————. — *L'Idée du peintre parfait.* London, 1707; rpt. Geneva, 1970.

——————. — *Noms des peintres les plus célèbres et les plus connus anciens & modernes.* Paris, 1679. rpt. Geneva, 1972.

*François Boucher, 1703–1770.* Exh. cat. The Metropolitan Museum of Art, New York, 1986.

FRASCINA, FRANCIS, ET AL.     *Modernism and Modernity: French Painting in the Nineteenth Century.* New Haven, Conn.: Yale University Press, 1993.

FRÈCHES-THORY, CLAIRE, AND ANTOINE TERRASSE.     *The Nabis: Bonnard, Vuillard, and Their Circle.* Trans., Mary Pardos, New York: Abrams, 1990.

GROOM, GLORIA LYNN.     *Edouard Vuillard, Painter-Decorator: Patrons and Projects, 1892 -1912.* New Haven: Yale University Press, 1993.

HARGROVE, JUNE, ED.     *The French Academy: Classicism and Its Antagonists.* Newark: University of Delaware Press, 1990.

HERBERT, ROBERT.     *Neo-Impressionism.* New York: Solomon R. Guggenheim Museum, 1968.

——————— .     *Impressionism, Art, Leisure, and Parisian Society,* New Haven, Conn.: Yale University Press, 1988.

HUTTON, JOHN.     *Neo-Impressionism and the Search for Solid Ground: Art, Science, and Anarchism in Fin-de-siècle France.* Baton Rouge: Louisiana State University Press, 1994.

JAWORSKA, WLADYSLAWA.     *Gauguin and the Pont-Aven School.* Trans., Patrick Evans. Greenwich, Conn.: New York Graphic Society, 1972.

JENSEN, ROBERT.     *Marketing Modernism in Fin-de-Siècle Europe.* Princeton: Princeton University Press, 1994.

LEE, ELLEN WARWDWELL.     *The Aura of Neo-Impressionism: The W.J. Holliday Collection.* Indianapolis: Indianapolis Museum of Art, 1983.

LE PAUL, JUDY.     *Gauguin and the Impressionists at Pont-Aven.* New York: Abbeville Press, 1987.

LEVEY, MICHAEL.     *Painting and Sculpture in France 1700-1789.* New Haven, Conn.: Yale University Press, 1993.

MOFFETT, CHARLES.     *The New Painting: Impressionism, 1874-1886.* Ed. Charles S. Moffett. San Francisco: Fine Arts Museums of San Francisco, 1986.

MONTAIGLON, A. DE, ED.     *Procés-verbaux de l'Académie Royale de Peinture et de Sculpture, 1646-1793.* 10 vols. Paris, 1875-1892.

MULLER, JOSEPH-EMILE,     *Fauvism.* New York and Washington: Paeger, 1967.

NOCHLIN, LINDA.     *The Politics of Vision: Essays on Nineteenth-Century Art and Society,* 1970.

——————— .     *Post-Impressionism: Cross-Currents in European Painting.* London: Royal Academy of Arts, 1979.

OPPERMAN, HAL     *J. B. Oudry, 1686-1755.* Exh. cat. Galeries nationales du Grand Palais, Paris, 1982; Kimbell Art Museum, Fort Worth, 1983.

PEVSNER, NIKOLAUS.      *Academies of Art Past and Present.* Cambridge, 1940; ed. New York: Da Capo, 1973.

PUTTFARKEN, THOMAS.      *Roger de Piles' Theory of Art.* New Haven: Conn.: Yale University Press, 1985.

RATLIFF, FLOYD.      *Paul Signac and Color in Neo-Impressionism.* New York: Rockefeller University Press, 1992.

REWALD, JOHN.      *Post-Impressionism from van Gogh to Gauguin,* 3rd ed. New York: Metropolitan Museum of Art, 1994.

ROSENBERG, PIERRE.      *France in the Golden Age: Seventeenth-Century French Paintings in American Collections.* Exh. cat. The Metropolitan Museum of Art, New York, 1982.

ROSENBLUM, ROBERT.      *Transformations in Late Eighteenth Century Art.* Princeton, N.J.: Princeton University Press, 1974.

SCHNEIDER, NORBERT.      *The Art of the Still Life: Still Life Painting in the Early Modern Period.* Cologne: Benedikt Taschen, 1990.

SÉRUSIER, PAUL.      *L'ABC de la peinture.* Paris: Liabrairie Floury, 1950. [Originally published, 1921]

SHACKELFORD, GEORGE T .M.      *Masterpieces of Baroque Painting from the Collection of the Sarah Campbell Blaffer Foundation.* Exh. cat. The Museum of Fine Arts, Houston, 1992.

SIGNAC, PAUL.      *D'Eugéne Delacroix au néo-impressionnisme.* Paris: Hermann, 1978. [Originally published, 1899]

SMITH, ANTHONY D.      "The 'Historical Revival' in Late 18th-Century England and France." *Art History*, 2, no. 2 (June 1979), 156-178.

SPARTI, DONATELLA L.      "Criteri museografici nella collezione dal Pozzo alla luce di documen tazione inedita." In F. Solinas, ed. *Cassiano dal Pozzo: Atti del Seminario Internazionale di Studi, pp. 221-240.* Rome, 1989.

STEADMAN, WILLIAM E.      *Homage to Seurat: Paintings, Watercolors, and Drawings by the Followers of Seurat.* Tucson: University of Arizona Art Museum, 1968.

STERLING, CHARLES.      *Still Life Painting from Antiquity to the Twentieth Century.* 2nd ed. New York, 1981.

SUTTER, JEAN, ED.      *The Neo-Impressionists.* Trans. Chantal Deliss. Greenwich, Conn.: New York Graphic Society, 1970.

THOMSON, BELINDA.      *Vuillard.* New York: Abbeville Press, 1988.

THOMSON, RICHARD,      *Seurat.* Oxford: Phaidon Press, 1985.

THULLIER, J.,                    *French Painting from Le Nain to Fragonard.* Geneva: Skira, 1964.
AND A. CHÂTELET.

TINTEROW, GARY, AND              *Origins of Impressionism.* New York: Metropolitan Museum of Art, 1994.
HENRI LOYRETTE.

WHITE, HARRISON C.               *Canvases and Careers: Institutional Change in the French Painting World.*
AND CYNTHIA A. WHITE.            Chicago: University of Chicato Press, 1993.

ZIMMERMAN, MICHAEL F.            *Seurat and the Art Theory of His Time.* Antwerp: Fonds Mercator, 1991.

# Exhibition
# Checklist

Fig. 67
Gustave Doré (1832 - 1883)
*Castle on the Rhone*
(*Un château sur La Rhône*), c. 1878
oil on canvas, signed lower left *G. Doré*, (39-3/8 in. x 28-7/8 in.)
Private Collection, San Antonio, Texas

# PAINTINGS

Artist Unknown, French 18th Century
*Portrait of André Ernest Gretry*
*(Portrait d'André Ernest Gretry)*, c. 1780s
oil on canvas, (20-1/2 in. x 18 in.)
The Sarah Campbell Blaffer Foundation, Houston, Texas
(Fig. 68 )
▼

Louis Anquetin (1861 - 1932)
*Two Men Talking*
*(Deux hommes causant)*, 1892
oil on canvas, signed lower left
and dated, (51-1/4 in. x 38-3/4 in.)
Private Collection, San Antonio, Texas
(Fig. 4)

Bonaventure de Bar (1700 - 1729)
*Country Fair (Fête champêtre)*, late 1720s
oil on canvas, (7 in. x 11-1/2 in.)
The Sarah Campbell Blaffer Foundation,
Houston, Texas
(Fig. 21)

Henri-Alphonse Barnoin (1882 - 1935)
*Rouen, from the Pathway, Le Cours La Reine*
*(Rouen, depuis Le Cours La Reine)*, 1922
oil pastel on paper, signed and dated lower left,
(38 in. x 51-1/2 in.)
Private Collection, San Antonio, Texas

Emile Bernard (1868 - 1941)
*Portrait of Nabi Sculptor Georges Lacombe*
*(Portrait du sculpteur Nabi Georges Lacombe)*, 1888
oil on canvas, signed and dated lower right
1888 (16-1/4 in. x 13 in.)
Private Collection, San Antonio, Texas
(Fig. 64)

Emile Bernard (1868 - 1941)
*Study of Two Bathers under a Willow Tree*
*(Étude de nus sous un saule)*, 1891
oil on panel, signed lower right and dated '91,
(18-1/2 in. x 14-1/2 in.)
Private Collection, San Antonio, Texas
(Fig. 63)

▲

Pierre Bonnard (1867 - 1947)
*Market Woman of the Four Seasons*
(*La Femme de marché des quatres saisons*), 1904
oil on canvas, signed lower left *Bonnard*,
(21-3/4 in. x 24-5/8 in.)
Private Collection, Austin, Texas
(Fig. 69)

Pierre Bonnard (1867 - 1947)
*Woman with Mirror and Orchids*
(*Femme avec miroir et orchidées*), n.d.
oil on canvas, (39-1/2 in. x 31-1/2 in.)
The Sarah Campbell Blaffer Foundation, Houston, Texas

François Boucher (1703 - 1770)
*The Cherub Harvesters*
(*Les Amours moissonneurs*), c. 1733-34
oil on canvas, (49-1/2 in. x 37-1/2 in.)
The Sarah Campbell Blaffer Foundation, Houston, Texas
(Fig. 25)

Workshop of the Boucicaut Master
French School, (c. 1410)
Four Illuminated Miniatures
(Quatre miniatures illuminées), 15th century
a. *St.Martin Dividing his Cloak*
   (*St.Martin divise sa manteau*) (5-1/2 in. x 3-15/16 in.)
b. *St. James the Great* (*St. James le grand*)
   (5-1/2 in. x 4 in.)
c. *Annunciation* (*L'Annonciation*)
   (6-5/8 in. x 4-7/8 in.), (Fig. 15)
d. *Crucifixion* (*Le Crucifixion*), (6-5/8 in. x 4-7/8 in.)
tempera and gilding on vellum
The Sarah Campbell Blaffer Foundation, Houston, Texas

Peter van Boucle (1600 - 1673)
*Still Life with Carp and Pike*
(*Nature-Morte avec la carpe et le brochet* ), 1652
oil on canvas,  (31-1/2 in. x 39-3/4 in.)
The Sarah Campbell Blaffer Foundation, Houston, Texas
(Fig. 38)

Eugène Boudin (1824 - 1898)
*Fishing Boats at St. Valéry*
(*Les Bateaux à St. Valéry*), 1891
oil on canvas, signed and dated lower right
*E. Boudin* 91
(18-1/4 in. x 25-5/8 in.)
Memphis Brooks Museum of Art, Memphis, Tennessee
Gift of Mr. and Mrs. Hugo N. Dixon

▲

William Adolphe Bouguereau (1825 -1905)
*From the Lookout*
(*Du Perchoir* ), 1896
oil on canvas, signed lower right *W. Bouguereau*,
(50-3/4 in. x 32 in.)
Private Collection, San Antonio, Texas
(Fig. 70)

William Adolphe Bouguereau (1825-1905)
*Admiration (Admiration)*, 1897
oil on canvas, (58 in. x 78 in.)
San Antonio Museum of Art, San Antonio, Texas
Bequest of Mort D. Goldberg
(Frontispiece)

Georges Braque (1882 - 1963)
*Landscape at L'Estaque (Paysage à L'Estaque)*, 1906
oil on canvas, (20 in. x 23-3/4 in.)
New Orleans Museum of Art, New Orleans, Louisiana
Bequest of Victor K. Kiam
(Fig. 66)

Georges Braque (1882 - 1963)
*Carafe, Grapes and Lemon
(Carafe, raisins, et citron)*, 1924
oil on canvas, signed lower right, *G. Braque*
(12 in. x 25-3/8 in.)
Private Collection, Austin, Texas

▲
Georges Braque (1882 - 1963)
*Woman with Mandolin
(Femme à la mandoline)*, 1936
oil on canvas, signed lower right
(13-1/2 in. x 10-1/2 in.)
Private Collection, San Antonio, Texas
(Fig. 71)

Victor Brauner (1903 - 1966)
*The Two Mothers (Les deux Mamans)*, 1948
oil on canvas, (23-3/8 in. x 23-2/4 in.)
The Menil Collection, Houston, Texas

Felix-Saturin Brissot de Warville (1818 - 1892)
*Herd of Sheep (Un Troupeau de moutons)*, 1880
oil on canvas, signed lower left
(45 in. x 57-1/2 in.)
Private Collection, San Antonio, Texas

▲
Eugène Carrière (1849 - 1906)
*Maternity (La Maternité)*, n.d.
oil on canvas, (12-5/8 in. x 15-3/4 in.)
Private Collection,
San Antonio, Texas
(Fig. 72)

Paul Cézanne (1839 - 1906)
*Rooftops (Les Toits)*, n.d.
oil on canvas, (25-7/8 in. x 32-1/8 in.)
Private Collection, Dallas, Texas
(Fig. 44)

Philippe de Champaigne (1602 - 1673)
*St. Arsenius Leaving the World
(St. Arsenius quitte le monde)*, c. 1650
oil on canvas, (23-5/8 in. x 30-1/4 in.)
The Sarah Campbell Blaffer Foundation, Houston, Texas
(Fig. 19)

Jean Baptiste Siméon Chardin (1699 - 1779)
*Still Life With Joint of Lamb*
*(Nature-Morte avec agneau)*, 1730
oil on canvas, (15-3/4 in. x 12-3/4 in.)
The Sarah Campbell Blaffer Foundation, Houston, Texas
(Fig. 40)

Jean-Baptiste-Camille Corot (1796 - 1875)
*The Mill and Three Cows. Contelea Road, near Rouen*
*(Un Moulin et trois vaches. Route de Contelea, près de Rouen)*, 1871,
oil on canvas, signed lower right
*Corot* (19-1/4 in. x 23-1/4 in.)
Private Collection, San Antonio, Texas
(Fig. 46)

Paul Gustave Courbet (1819 - 1877)
*Roe Deer at a Stream* (*Un Daim au ruisseau*), 1868
oil on canvas, signed and dated lower right *G. Courbet*,
(38-3/8 in. x 51-1/8 in.)
Kimbell Art Museum, Fort Worth, Texas
(Fig. 42)

Paul Gustave Courbet (1819 - 1877)
*The Lake, near Saint-Point*
*(Le Lac, environs de Saint-Point)*, 1872
oil on canvas, signed lower left *G. Courbet*
(19-1/4 in. x 23-1/8 in.)
Private Collection, San Antonio, Texas
(Fig. 47)

Lucie Coustourier (1870 - 1925)
*Woman Dozing (Femme assoupie)*, c. 1900
oil on canvas, signed lower center
(31-1/2 in. x 26-1/2 in.)
Private Collection, San Antonio, Texas
(Fig. 60)

▲

Charles François de la Croix de Marseilles (d.1782)
*Harbor and Boats* (*Un Port et des bateaux*), n.d.
oil on paper, mounted on canvas, signed lower left,
(29-3/4 in. x 51-1/4 in.)
Private Collection, San Antonio, Texas
(Fig. 73)

Charles François de la Croix de Marseille (d. 1782)
*An Italian Port Scene (Le Port italien)*, 1770
oil on canvas, (35-1/2 in. x 72 in.)
The Sarah Campbell Blaffer Foundation, Houston, Texas
(Fig. 36)

Henri-Edmond Cross (1856 - 1910)
*Mediterranean Shore (Bords Méditerranéens)*, 1895
oil on canvas, signed lower left
(25-3/4 in. x 36-1/2 in.)
Private Collection, San Antonio, Texas
(Cover)

Charles-François Daubigny (1817 - 1878)
*The Reapers (Les Faucheurs)*, c. 1870
oil on canvas, (51-1/2 in. x 77-1/4 in.)
Private Collection, New York
(Fig. 51)

Robert Delaunay (1885 - 1941)
*The Eiffel Tower* (*La Tour Eiffel*), 1924
oil on canvas, (72-1/2 in. x 68-1/2 in.)
Dallas Museum of Art
Gift of the Meadows Foundation, Incorporated
(Fig. 13)

Alexandre-François Desportes (1661 - 1743)
*Still Life with Dog and Game*
(*Nature-Morte avec un chien et du gibier*), 1710
oil on canvas, (32-1/4 in. x 40-3/8 in.)
The Sarah Campbell Blaffer Foundation, Houston, Texas
(Fig. 74)
▼

Narcisse Virgile Diaz de la Peña (1807 - 1876)
*The Gypsy Princesses* (*Les Princesses gitane*s), c. 1865-70
oil on panel, (31-1/2 in. x 23-3/4 in.)
Private Collection, San Antonio, Texas
(Fig. 7)

Gustave Doré (1832 - 1883)
*Castle on the Rhone*
(*Un château sur La Rhône*), c. 1878
oil on canvas, signed lower left *G. Doré*,
(39-3/8 in. x 28-7/8 in.)
Private Collection, San Antonio, Texas
(Fig. 67)

Michel Dorigny (1617 - 1665)
*Hagar and the Angel* (*Hagar et l'ange*), c. 1645-50
oil on canvas, (55-3/4 in. x 42-3/8 in.)
The Sarah Campbell Blaffer Foundation, Houston, Texas
(Fig. 18)

Albert Dubois-Pillet (1845 - 1890)
*The Towers of Saint Sulpice*
(*Les Tours de Saint Sulpice*), c. 1888
oil on canvas, (32 in. x 23-3/4 in.)
Private Collection, San Antonio, Texas
(Fig. 54)

Raoul Dufy (1877 - 1953)
*Woman in Pink* (*Dame en rose*), 1908
oil on canvas, (45-3/4 in. x 35 in.)
The Sarah Campbell Blaffer Foundation,
Houston, Texas
(Fig. 75)▶

Aimée Duvivier (1786 - 1824)
*The Marquis D'Acqueville*
(*Le Marquis D'Acqueville*), 1791
oil on canvas, (46-7/8 in. x 35-1/8 in.)
Archer M. Huntington Gallery,
The University of Texas at Austin
Gift of Mr. and Mrs. Clark W. Thompson, Sr.
(Fig. 76)
▼

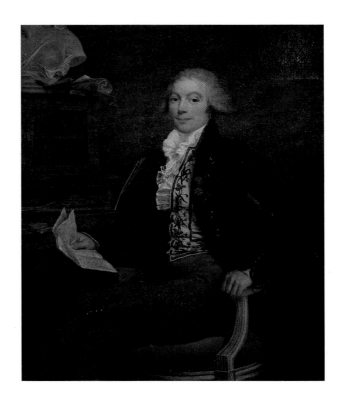

Henri-Antoine de Favanne (1668 - 1752)
*Athena Protecting Alexander the Great Before Darius*
(*Athéna défend Alexandre devant Darius*), c. 1725
oil on canvas, (37 in. x 49-1/2 in.)
The Sarah Campbell Blaffer Foundation, Houston, Texas
(Fig. 27)

▲
François Flameng (1856 - 1923)
*Ellen Banning Ayer*
(*Ellen Banning Ayer*), 1897
oil on canvas, signed lower right *François Flameng*
(44-1/2 in. x 33-3/4 in.)
Private Collection, San Antonio, Texas
(Fig. 77)

Jean-Honoré Fragonard (1732 - 1806)
*Boy Leading a Cow*
(*Enfant conduisant une vache*), 1760s
oil on canvas, (21-1/4 in. x 26 in.)
The Sarah Campbell Blaffer Foundation, Houston, Texas

Othon Friesz (1878 - 1949)
*Cassis* (*Cassis*), 1907
oil on canvas, signed lower right and dated '07
(21-1/4 in. x 25-1/4 in.)
Private Collection, San Antonio, Texas
(Fig. 65)

Paul Gauguin (1848 - 1903)
*Path Behind the Palms, Martinique*
(*Le Chemin derrière des palmiers, Martinique*), 1887
oil on canvas, (35-1/8 in. x 23-3/4 in.)
Private Collection, Dallas, Texas
(Fig. 1)

Paul Gauguin (1848 - 1903)
*Sister of Charity*
(*Soeur de Charité*), 1902
oil on canvas, (25-3/4 in. x 30 in.)
McNay Art Museum, San Antonio, Texas
Bequest of Marion Koogler McNay
(Fig. 79)
▼

Jean-Leon Gérôme (1824 - 1904)
*Tiger on the Watch* (*Le Tigre en garde*), c. 1888
oil on canvas, (25 in. x 35-5/8 in.)
The Museum of Fine Arts, Houston
Gift of the Houston Art League
George M. Dickson Bequest
(Fig. 6 )

Jean-Baptiste-Armand Guillaumin, (1841 - 1927)
*The River Oise at Auvers (L'Oise à Auvers)*, 1873
oil on canvas, signed lower left *Guillaumin*
(13 in. x 18 in.)
Private Collection, San Antonio, Texas
(Fig. 50)

Jean-Baptiste-Armand Guillaumin, (1841 - 1927)
*Still Life-Fruit, Pitcher and Vegetables*
*(Nature Morte-fruits, pichet et légumes)*, c. 1910
oil on canvas, signed lower left, (24 in. x 28-3/4 in.)
Private Collection, San Antonio, Texas
(Fig. 82) ▼

▲
Albert Gleizes (1881 - 1953)
*Woman with Phlox (Femme avec Phlox)*, 1910
oil on canvas, (32-1/8 in. x 39-7/16 in.)
The Museum of Fine Arts, Houston
Gift of the Esther Florence Whinery
Goodrich Foundation
(Fig. 80)

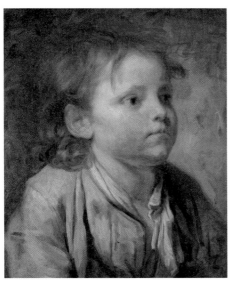

Jean-Baptiste Huet (1745 - 1811)
*Landscape with Shepherdess and Boy Fishing*
*(Paysage avec une bergère et un pêcheur)*, 1793
oil on canvas, (31-1/3 in. x 37-7/8 in.)
The Sarah Campbell Blaffer Foundation, Houston, Texas
(Fig. 37)

▲
Jean-Baptiste Greuze (1725 - 1805)
*Head of a Young Boy*
*(Tête d'un garçon)*, 1760s
oil on canvas (24 in. x 19 in.)
The Sarah Campbell Blaffer Foundation, Houston, Texas
(Fig. 81)

Pierre-Nicolas Huillot (1674 - 1751)
*Still Life with Silver and Gold Vessels, Fruit and Flowers*
*(Nature-Morte avec les Vaisseaux d'or et d'argent, des fruits*
*et des fleurs)*, 1718
oil on canvas, (105-1/2 in. x 86 in.)
The Sarah Campbell Blaffer Foundation, Houston, Texas
(Fig. 39)

Laurent de la Hyre (1606 - 1656)
*Allegorical Figure of Geometry*
*(La Géometrie, figure allégorique),* 1650
oil on canvas, (circular, 41-1/2 in. diameter)
The Sarah Campbell Blaffer Foundation, Houston, Texas
(Fig. 24)

George Lacombe (1868 - 1916)
*The Woodcutter and the Woman*
*(Le Bûcheron et la femme),* 1896
oil on canvas, (45-1/4 in. x 63-3/4 in.)
Private Collection, San Antonio, Texas
(Fig. 62)

▲

Nicolas Lancret (1690 - 1743)
*The Amorous Turk (Le Turc amoureux),* c. 1730-5
oil on canvas, (27-11/16 in. x 18-3/8 in.)
The Sarah Campbell Blaffer Foundation, Houston, Texas
(Fig. 34)

Albert Lebourg (1849 - 1928)
*The Seine at Marly in Winter*
*(La Seine à Marly en hiver),* 1895
oil on canvas, signed lower right, (18-1/4 in. x 30 in.)
Private Collection, San Antonio, Texas
(Fig. 83)

Nicolas Lancret (1690 - 1743)
*The Captive Bird (L'Oiseau prisonnier),* c. 1730
oil on canvas, (11-5/8 in. x 15-5/8 in.)
The Sarah Campbell Blaffer Foundation, Houston, Texas
(Fig. 33)

Charles Le Brun (1619 - 1690)
*The Road to Calvary (La Route à Calvarie),* c. 1645
oil on canvas, (57 in. x 77 in.)
The Sarah Campbell Blaffer Foundation, Houston, Texas
(Fig. 26)

Nicolas Largillière (1656 - 1746)
*Portrait of Pierre Cadeau de Mongazon (Portrait de Pierre*
*Cadeau de Mongazon),* c. 1720 s
oil on canvas, (32 in. x 25-1/2 in.)
The Sarah Campbell Blaffer Foundation, Houston, Texas
(Fig. 30)

Fernand Lèger (1881 - 1955)
*Study of the Beautiful Dancers*
*(Étude pour les belles danseuses),* 1929
oil on canvas, (35-3/4 in. x 28-1/4 in.)
The Sarah Campbell Blaffer
Foundation, Houston, Texas
(Fig. 84)

◀

Jean Lemaire, called Lemaire-Poussin (1597/8 - 1659)
*Mercury and Argus* (*Mercure et Argus*), 1650s
oil on canvas,  (29 in. x 38 in.)
The Sarah Campbell Blaffer Foundation, Houston, Texas
(Fig. 35)

François Le Moyne (1688 - 1737)
*The Adoration of the Magi*
(*L'Adoration des rois mages*), 1716
oil on canvas, ( 39-1/4 in. x 32 in. )
The Sarah Campbell Blaffer Foundation, Houston, Texas
(Fig. 20)

Jean-Baptiste Leprince (1734 - 1781)
*The Tartar Camp* (*La Halte des Tartares*), c. 1765
oil on canvas,  (69 in. x 87-3/4 in.)
The Sarah Campbell Blaffer Foundation, Houston, Texas
(Fig. 23)

Maximilien Luce (1858 - 1941)
*The Louvre and the Pont du Caroussel, At Night*
(*Le Louvre et le Pont du Caroussel, Effet du Nuit*), 1890
oil on canvas, signed and dated '90, (25 in. x 32 in.)
Private Collection, San Antonio, Texas
(Fig. 55)

Maximilien Luce (1858 - 1941)
*Factory Chimneys, Couillet near Charleroi*
(*Les Cheminées d'usines, Couillet près de Charleroi*), c. 1899
oil on canvas, signed and dated lower right
(29 in. x 39-1/3 in.)
Private Collection, San Antonio, Texas
(Fig. 57)

Maximilien Luce (1858 - 1941)
*Portrait of the Artist Charles Angrand*
(*Portrait du peintre Charles Angrand*), 1908
oil on canvas, signed lower left, (28 in. x 23-1/2 in.)
Private Collection, San Antonio, Texas
(Fig. 58)

Corneille de Lyon (c. 1500 - 1574)
*Portrait of a Woman (Portrait d'une femme)* c. 1540s
oil on panel, (6-3/8 in. x 5-1/4 in.)
The Sarah Campbell Blaffer Foundation, Houston, Texas
(Fig. 28)

▲

Henri Manguin (1874 - 1949)
*Still Life on Oriental Rug*
(*Nature Morte au Tapis Oriental*), 1912
oil on canvas, signed lower right, (32 in. x 39-1/2 in.)
Private Collection, San Antonio, Texas
(Fig. 85)

Henri Matisse (1869 - 1954)
*The Red Blouse (La Blouse Rouge)*, 1936
oil on canvas, (18-3/8 in. x 13-1/8 in.)
McNay Art Museum, San Antonio, Texas
Bequest of Marion Koogler McNay
(Fig. 8)

Jean Metzinger (1883 - 1957)
*Pointillist Landscape*
(*Paysage Pointilliste*), 1906-1907
oil on canvas, signed lower right
(25-3/4 in. x 35-1/4 in.)
Private Collection, San Antonio, Texas
(Fig. 59)

Jean Metzinger (1883 - 1957)
*Woman with Grapes (Femme avec raisins)*, 1916-17
oil on canvas, signed lower left, (31-1/2 in. x 39 in.)
Private Collection, San Antonio, Texas

Jean Michelin (1623 - 1696)
*The Poultry Sellers*
(*Les Vendeurs de volaille*), c. 1660s
oil on canvas,  (25-5/8 in. x 32-5/8 in.)
The Sarah Campbell Blaffer Foundation, Houston, Texas
(Fig. 32)

Henri Moret (1856 - 1913)
*The Village of Lampaul, Isle of Ouessant*
(*Le Village de Lampaul, Île d' Ouessant*), 1895
oil on canvas, signed and dated lower left '95
(28-3/4 in. x 23-3/4 in.)
Private Collection, San Antonio, Texas
(Fig. 61)

▲

Pierre Mignard (1612 - 1695)
*Pan and Syrinx*, (*Pan et Syrinx*) c. 1688-90
oil on canvas, (28-3/4 in. x 38-1/2 in.)
The Sarah Campbell Blaffer Foundation, Houston, Texas
(Fig. 86)

Jean Marc Nattier (1685 - 1766)
*Portrait of a Gentleman Hunter*
(*Portrait d'un gentilhomme en chasseur*), 1727
oil on canvas, (46 in. x 35-1/2 in.)
The Sarah Campbell Blaffer Foundation, Houston, Texas
(Fig. 31)

Jean-Baptiste Oudry (1686 - 1755)
*Allegory of Europe*, (*Europe, figure allégorique*), 1722
oil on canvas, (63-3/4 in. x 59-3/4 in.)
The Sarah Campbell Blaffer Foundation, Houston, Texas
(Fig. 22)

Claude Monet (1840 - 1926)
*Springtime in Giverny, Afternoon*
(*Printemps à Giverny, effet d'aprés-midi*), 1885
oil on canvas, (24 in. x 32 in.)
Museum of Fine Arts, St. Petersburg
St. Petersburg, Florida
Extended Anonymous Loan
(Fig. 48)

Francis Picabia (1878 - 1953)
*Moret, Morning*
(*Moret, Effet du Matin*), 1904
oil on canvas, signed upper
right and dated 1904
(36-1/4 in.x 29 in.)
Private Collection, San Antonio, Texas
(Fig. 87)

▼

Claude Monet (1840 - 1926)
*Poplars, Pink Effect*
(*Les Peupliers, Effet du rose*), 1891
oil on canvas, signed and dated lower left
*Claude Monet '91*, (42-1/2 in. x 29-3/8 in.)
Private Collection, Dallas, Texas
(Fig. 41)

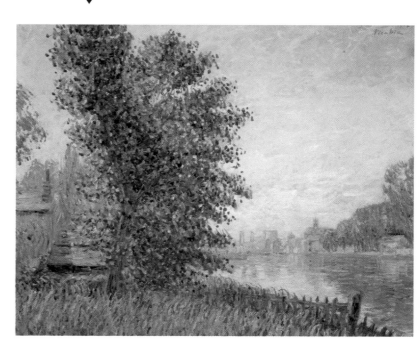

School of Picardie, (15th century)
*The Pietà (La Pietà)* 15th century
oil on panel, (27-1/2 in. x 12-1/4 in. )
The Sarah Campbell Blaffer Foundation, Houston, Texas
(Fig. 88)

Robert Pinchon (1886 - 1943)
*The Quai St. Sever in the Snow at Rouen*
(*Le Quai St. Sever sous la neige à Rouen*), c. 1929
oil on canvas, signed lower right
(31-1/2 in. x 55-1/2 in.)
Private Collection, San Antonio, Texas

Camille Pissarro (1830 - 1903)
*Peasant Carrying Two Bales of Hay*
(*Un Paysan portant deux bottes*), 1883
oil on canvas, (27-7/8 in. x 23-5/8 in.)
Dallas Museum of Art
Gift of the Meadows Foundation, Inc.
(Fig. 45)

Jean-Baptiste-Marie Pierre
(1713-1789)
*The Rape of Europa*
(*L' Enlèvement d'Europe*), 1759
oil on canvas
(20-1/4 in. x 27-1/8 in.)
The Sarah Campbell Blaffer
Foundation, Houston, Texas
(Fig. 89)
▶

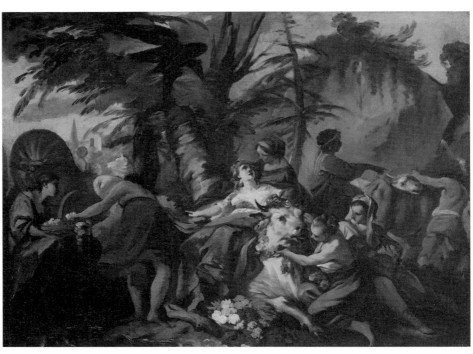

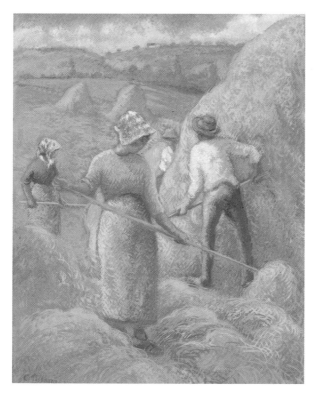

▲
Camille Pissarro (1830 - 1903)
*Haying (La Fenaison)*, n.d.
oil on canvas, (15 in. x 11-3/4 in.)
Private Collection, San Antonio, Texas
(Fig. 90)

Pierre Puvis de Chavannes (1824 - 1898)
*The Woodcutters (Les Bûcherons)*, 1871-1874
oil on paper, mounted on canvas, (29-1/2 in. x 45 in.)
Private Collection, San Antonio, Texas
(Fig. 53)

▲
Jean Francois Raffaelli (1850 - 1924)
*View of the Boulevard des Italiens, near Notre Dame de
Lorette (Vue du Boulevard des Italiens, près de
Notre Dame de Lorette)*, c. 1885
oil, gouache and watercolor on brown paper laid down on
board, (27-1/4 in. x 34-3/4 in.)
Private Collection, San Antonio, Texas
(Fig. 91)

Auguste Renoir (1841 - 1919)
*Picking Flowers (La Cueillaison des Fleurs)*, 1875
oil on linen, (21 3/8 in. x 25 5/8 in.)
National Gallery of Art, Washington, D.C.
Ailsa Mellon Bruce Collection
(Fig. 49)

Pierre Auguste Renoir (1841 - 1919)
*Woman Bathing (La Baigneuse)*, 1896
oil on canvas, signed lower left *Renoir*
(16-1/8 in. x 12-5/8 in.)
Private Collection, San Antonio, Texas
(Fig. 5)

Hubert Robert (1733 - 1808)
*The Fountain (La Fontaine)*, c. 1760-65
oil on canvas, (44-1/2 in. x 35-1/2 in.)
Kimbell Art Museum, Fort Worth, Texas

Hubert Robert (1722-1808)
*The Burning of the Hotel Dieu*
*(L'Incendie de l'Hôtel Dieu)* 1770s
oil on canvas, (100-1/2 in. x 65-1/4 in.)
The Sarah Campbell Blaffer Foundation, Houston, Texas
(Fig. 92) ▼

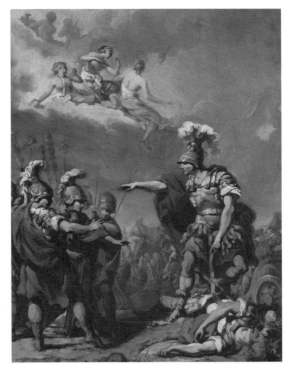

▲
Jacques-Henri Sablet (1749 - 1803)
*The Death Of Pallas (La Mort de Pallas)*, 1778
oil on paper mounted on canvas, (18-1/2 in. x 13-1/2 in.)
The Sarah Campbell Blaffer Foundation, Houston, Texas
(Fig. 93)

Paul Sérusier (1863 - 1927)
*Landscape at Le Pouldu (Paysage à Le Pouldu)*, 1890
oil on canvas, (29-1/4 in. x 36-1/4 in.)
The Museum of Fine Arts, Houston
Gift of Alice C. Simkins in
memory of Alice N. Hanszen
(Fig. 56)

Alfred Sisley (1839 - 1899)
*Bougival (Bougival)*, 1876
oil on canvas, (24-1/2 in. x 29 in.)
Cincinnati Art Museum, Cincinnati, Ohio
John J. Emery Fund
(Fig. 43)

Pierre Soulages (b. 1919)
*August 22, '61 (22 Aôut '61)*, 1961
oil on canvas, (78-3/4 in. x 110-3/4 in.)
The Museum of Fine Arts, Houston
Museum purchase
(Fig. 94) ▼

Nicolas de Staël (1914 - 1955)
*Still Life (Nature-Morte)*, 1953-1954
oil on canvas, (28-1/2 in. x 39-3/8 in.)
The Sarah Campbell Blaffer Foundation, Houston, Texas
(Fig. 95) ▼

Nicholas Tournier (1590 - 1657)
or Valentin de Boulogne (1591 - 1632)
*St. Paul (St. Paul)*, c. 1625
oil on canvas (39-1/8 in. x 52-3/8 in.)
The Sarah Campbell Blaffer Foundation, Houston, Texas
(Fig. 16)

François de Troy (1645 - 1730)
*Self-Portrait (Autoportrait)* c. 1704
oil on canvas, (46 in. x 35-3/4 in.)
The Sarah Campbell Blaffer Foundation, Houston, Texas

Maurice Utrillo (1883 - 1955)
*The Moulin de La Galette at Montmartre
(Le Moulin de La Galette à Montmartre)*, 1935
oil on canvas, signed and dated lower right
(25-5/8 in. x 19-3/4 in.)
Mr. Walter F. Brown, Jr., San Antonio, Texas
(Fig. 2)

Ludovic de Vallee (1864-1939)
*The Beach at the Foot of the Bluff
(La Plage au pied de la falaise)*, 1924-26
oil on canvas, signed lower left
(36-3/4 in. x 46-1/2 in.)
Private Collection, San Antonio, Texas

▲

Louis Valtat (1869 - 1952)
*Woman in the Garden (Femme au Jardin)*, 1902
oil on canvas, signed lower right (32-1/8 in. x 39-1/2 in.)
Private Collection, San Antonio, Texas
(Fig. 96)

Carle van Loo (1705 - 1765)
*Mars and Venus (Mars et Venus)* c. 1730
oil on canvas, (32 in. x 26 in.)
The Sarah Campbell Blaffer Foundation, Houston, Texas
(Fig. 14)

Simon Vouet (1590 - 1649)
*St. Sebastian (St. Sebastien)*, c. 1618-20
oil on canvas, (37-3/4 in. x 29 in.)
The Sarah Campbell Blaffer Foundation, Houston, Texas
(Fig. 17)

Édouard Vuillard (1868 - 1940)
*Mrs. Tristan Bernard (Madame Tristan Bernard)*, 1914
oil on canvas, signed and dated lower left
(71 in. x 61-1/2 in.)
Private Collection, San Antonio, Texas
(Fig. 52)

## SCULPTURE

Arman (b. 1928)
*Heroic Suffragette (Suffragette hèroique)*, 1963
cut metal casting and screws embedded in synthetic resin
and mounted in a painted wood shadow box
(28-1/4 in. x 36-1/4 in. x 2-3/8 in.)
The Menil Collection, Houston, Texas

Louis Ernest Barrias (1841 - 1905)
*Nature Undressed Before Science (La Nature se dévoilant
devant la Science)*, 1893
bronze with gold and
silver patina
(28-1/4 in. high)
Private Collection
San Antonio, Texas
(Fig. 97) ▶

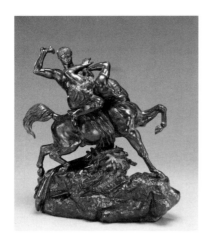

▲

Antoine Barye (1795 - 1875)
*Theseus Fighting the Centaur Biénor*
(*Thésée combattant le centaure Biénor*) 1880
bronze, (16 in. high)
Private Collection, San Antonio, Texas
(Fig. 98)

Antoine Bofill (1895 - 1925)
*Mermaid on a Rearing Horse*
(*Une Sirène sur un cheval cabré*), n.d.
bronze, (30-1/4 in. high)
Private Collection, San Antonio, Texas
(Fig. 99) ▼

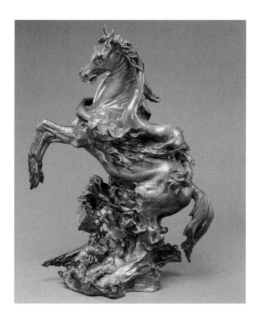

Georges Braque (1882 - 1963)
*Hymen* (*Hymen*), 1939
bronze, ed. 2/6, (29-5/8 in. x 20-1/8 in. x 13 in.)
Patsy R. and Raymond D. Nasher Collection
Dallas, Texas
(Fig. 100) ▼

Georges Braque (1882 - 1963)
*Horse Head* (*Tête de cheval*), n.d.
bronze and zinc sculpture, (17-3/4 in. x  6 in. x  35 in.)
Private Collection, Dallas, Texas

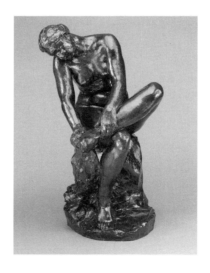

▲

Aimé-Jules Dalou (1838 - 1902)
*Woman Bathing with Raised Leg*
(*Baigneuse se levant le pied*), 1875
bronze, signed and numbered, (21-1/2 in. high)
Private Collection, San Antonio, Texas
(Fig. 101)

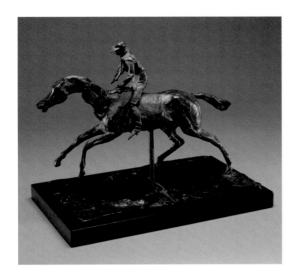

Paul Gauguin (1848 - 1903)
*Bust of Madam Schuffenecker (Buste de Madame Schuffenecker)*, c. 1889
bronze sculpture, ed. 9/10, (17 in. high)
Private Collection, San Antonio, Texas
(Fig. 104) ▼

▲
Edgar Degas (1834 - 1917)
*Horse with Jockey; Horse Galloping on Right Foot,*
*The Back Left Foot only Touching the Ground*
*(Cheval au galop sur le pied droit, le pied gauche touchant*
*la terre. Jockey monté sur le cheval)*, 1865-1881
bronze, incised with signature *Degas* on horse,
(9-3/8 in. high )
Private Collection, San Antonio, Texas
(Fig. 102)

Yves Klein (1928 - 1962)
*Sculpture S41-Blue Venus*
*(La Sculpture S41-Blue Venus)*, 1970
dry pigment on synthetic resin on plaster
(27 3/8 in. x 17 in. x 18 in.)
Margaret Marie Goldsbury
San Antonio, Texas

Jean-Alexandre-Joseph Falguière (1831 - 1900)
*Winner of the Cock Fight*
*(Le Vainqueur au combat de coqs)*, 1864
bronze, signed and numbered, (31 in. high)
Private Collection, San Antonio, Texas
(Fig. 103) ▼

Aristide Maillol (1861 - 1944)
*Marie (Marie)*, c. 1930
bronze, ed. 5/6, (27 in. x 8 in. x 13 in.)
Patsy R. and Raymond D. Nasher Collection
Dallas, Texas
(Fig. 105) ▶

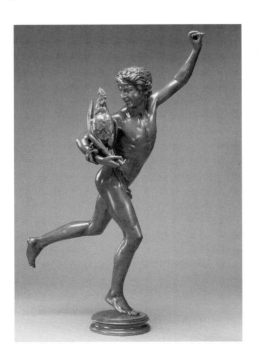

Mathurin Moreau (1822 - 1912)
*The Well* (*La Source*), n.d.
bronze, signed and numbered (17 in. high)
Private Collection, San Antonio, Texas
(Fig. 106)
◀

Pierre Auguste Renoir (1841 - 1919)
*Project for a Clock-Triumph of Love*
(*Projet pour une horloge-Le Triumphe
D'Amour*), 1914
bronze clock, no.3
(28 in. x 20 in. x 10-1/2 in.)
Private Collection, San Antonio, Texas
(Fig. 107) ▶

Pierre Auguste Renoir (1841 - 1919)
*Female Figure (Figure de femme)*, c. 1918
bronze relief, ed. 19/20, signed lower left *Renoir*
(24 3/8 in. x 17.25 in.)
Private Collection, San Antonio, Texas
(Fig. 10)

Pierre Auguste Renoir (1841 - 1919)
*Male Figure (Figure d' homme)*, c. 1918
bronze relief, ed. 5/20, signed lower right *Renoir*
(24 in. x 17-3/8 in.)
Private Collection, San Antonio, Texas
(Fig. 9)

Auguste Rodin (1840 - 1917)
*The Kiss (Le Baiser)*, c. 1884
bronze, (28-3/4 in. high)
Private Collection, San Antonio, Texas
(Fig. 108) ▶

Nikki de Saint Phalle (b. 1930)
*Untitled (Sans titre)*, n.d.
sculpture in two parts, (18 in. x 25 in. x 7 in. and
6-3/4 in. x 9 in. x 5-1/2 in.)
Private Collection
San Antonio, Texas

Nikki de Saint Phalle (b. 1930)
*The Moon (La Lune)*, 1984-85
painted polyester, ed. 5/10, (27-1/4 in. x 12 in. x 9-1/4 in.)
Private Collection, San Antonio, Texas

Nikki de Saint Phalle (b. 1930)
*The World (Le Monde)*, 1989
cast polyester, painted and gold leafed metal
base by Jean Tinguely, (27 in. high)
Private Collection, San Antonio, Texas

Nikki de Saint Phalle (b. 1930)
*The Force (La Force)*, 1987
cast in polyester resin, ed. 1/10, (22 in. x 13 in. x 14 in.)
Private Collection, San Antonio, Texas

## WORKS ON PAPER

Nicolas Beatrizet (1507 - 1565)
*Henry II, King of France (Henry II, Roi du France)*, 1558
engraving, (19-1/2 in. x 15-1/4 in.)
Archer M. Huntington Gallery
The University of Texas at Austin
Purchased through the generosity of the
Still Water Foundation

François Boucher (1703 - 1770)
*The Graces at the Tomb of Watteau
(Les Grâces à la tombe de Watteau)*, 1728
etching, (17-13/16 in. x 12-5/8 in.)
Archer M. Huntington Gallery,
The University of Texas at Austin
Archer M. Huntington Museum Fund

François Boucher (1703 - 1770)
*Juno Commanding Aeolus to Unleash the Winds (Junon
ordonndent Éole de  lâches ses vents)*, 1769
black chalk on cream antique laid paper
(8-7/8 in. x 11-3/4 in.)
Archer M. Huntington Art Gallery
The University of Texas at Austin
Archer M. Huntington Museum Fund
(Fig. 109) ▼

Georges Braque (1882 - 1963)
*Woman Sitting (Femme assise)*, 1934
etching on wove paper, (9-1/2 in. x 7-1/4 in.)
Private Collection, San Antonio, Texas

Jacques Callot (1592 - 1635)
*Beggar on Crutches (Le Mendiant sur béquille)*, n.d.
etching, (5-5/8 in. x 3-1/2 in.)
San Antonio Museum of Art, San Antonio, Texas
Bequest of Dr. Arthur Norman

Jacques Callot (1592 - 1635)
*Gentleman with a Large Cane*
*(Monsieur avec une grand canne)*, n.d.
etching, (2-1/4 in. x 3-3/8 in.)
San Antonio Museum of Art, San Antonio, Texas
Bequest of Dr. Arthur Norman

Jacques Callot (1592 - 1635)
*Gentleman and his Page (Monsieur avec son chasseur)*, n.d.
etching, (2-5/8 in. x 3-3/4 in.)
San Antonio Museum of Art, San Antonio, Texas
Bequest of Dr. Arthur Norman

Jacques Callot (1592 - 1635)
*Jesus and the Woman Taken in Adultery*
*(Jésus avec la femme adultère)*, n.d.
etching, (2-5/8 in. x 3-1/2 in.)
San Antonio Museum of Art, San Antonio, Texas
Bequest of Dr. Arthur Norman

Eugéne Carriere (1849 - 1906)
*Industrial Workers (Les Ouvriers industriels)*, 1900
lithograph, (54 in. x 39 in.)
Private Collection, San Antonio, Texas

Paul Cézanne (1836 - 1906)
*The Bathers (Les Baigneurs)*, 1897
lithograph printed in colors, (9 in. x 11-3/8 in.)
Private Collection, San Antonio, Texas

Charles-Nicolas Cochin, the Younger (1715 - 1790)
*Decorations of the State Room Constructed for the Marriage*
*of Louis, Dauphin of France, to Maria Theresa of Spain*
*(Décorations de la Salle de Spectacle Construite à*
*l'Occasion du Marriàge de Louis, Dauphin de France à*
*Maria Thérésa, Infanta d'Espagne)*, 1745
etching and engraving, (34-1/8 in. x 24-7/16 in.)
Archer M. Huntington Gallery
The University of Texas at Austin
Archer M. Huntington Museum Fund

Henri-Edmond Cross (1856 - 1910)
*On the Champs-Elysees*
*(Sur les Champs-Elysees)*, n.d.
color lithograph, (7-7/8 in. x 10-1/4 in.)
Private Collection, San Antonio, Texas

Honoré Daumier (1808 - 1879)
*Arrival at Lyon (Arrívée à Lyon)*, 1831
lithograph with hand coloring
(13-5/8 in. x 10-1/4 in.)
Archer M. Huntington Gallery,
The University of Texas at Austin
Purchased through the generosity of the
Still Water Foundation

Honoré Daumier (1808 - 1879)
*Les Papas (Les Papas)*, 1862
colored lithograph, (11-3/4 in. x 9 in. )
Private Collection, San Antonio, Texas

Edgar Degas (1834 - 1917)
*Study for "The Daughter of Jephthah"*
*(Étude pour "La Fille de Jephthah")*, 1861-64
pencil drawing, (12-1/4 in. x 7-1/2 in.)
Private Collection, Austin, Texas

Edgar Degas (1834 - 1917)
*Woman Getting Out of the Bath*
(*La Sortie de Bain*), 1879-80
electric crayon, etching, drypoint, aquatint
(9 x 6-1/2 in.)
Archer M. Huntington Art Gallery,
The University of Texas at Austin
Archer M. Huntington Museum Fund
(Fig. 110) ▼

Edgar Degas (1834 - 1917)
*Dancer Adjusting her Shoe*
*(Danseuse adjustant son soulier)*, c. 1885
pastel on paper, (19-7/16 in. x 23-3/4 in.)
The Dixon Gallery and Gardens
Memphis, Tennessee
Bequest of Mr. and Mrs. Hugo N. Dixon
(Fig. 3)

Eugène Delacroix (1798 - 1863)
*Lion of Atlas (Lion d'Atlas)*, 1829
lithograph, (13 in. x 18-1/2 in.)
McNay Art Museum, San Antonio, Texas
Museum Purchase
Exhibited for the first half of the exhibition.
(Fig. 111)
▼

Eugène Delacroix (1798 - 1863)
*Royal Tiger (Tigre royal)*, 1829
lithograph, (12-3/4 in. x 18-1/4 in.)
McNay Art Museum, San Antonio, Texas
Museum Purchase
Exhibited for the second half of the exhibition.

Maurice Denis (1870 - 1943)
*Madeleine, Two Heads (Madeleine, deux têtes)*, 1893
colored lithograph, (11-7/8 in. x 9-7/8 in.)
Private Collection, San Antonio, Texas

Maurice Denis (1870 - 1943)
*Woman in Clouds (Femme au nuages)*, n.d.
etching, (9-5/8 in. x 7-1/4 in.)
Private Collection, San Antonio, Texas

Achille-Jacques-Jean-Marie Devéria (1800 - 1857)
*Portrait of Victor Hugo*
(*Portrait de Victor Hugo*), 1829
lithograph mounted on china paper
(15 in. x 11-7/8 in.)
Private Collection, San Antonio, Texas

Jean Dubuffet (1901 - 1985)
*Mire G10 Bolivar* (*Mire G10 Bolivar*), 1983
acrylic on canvas backed paper
(26 1/2 in. x 32 1/2 in.)
David Christopher Goldsbury, San Antonio, Texas

Raoul Dufy (1877 - 1953)
*Arrival at New York* (*Arrivée à New York*), 1938
lithograph, (12-1/4 in. x 9-1/2 in.)
Private Collection, San Antonio, Texas

Etienne-Maurice Falconet (1716 - 1791)
*Untitled*, Designs after figurines by François Boucher
(*Sans titre*, aprés des figures de François Boucher)
c. 1757
etching, No. 1 of 6, (10-1/2 in. x 8-1/8 in.)
Private Collection, San Antonio, Texas

Etienne-Maurice Falconet (1716 - 1791)
*Untitled*, Designs after figurines by François Boucher
(*Sans titre*, aprés des figures de François Boucher)
c. 1757
etching, ed. 3/6, (10-1/2 in. x 8-1/8 in.)
Private Collection, San Antonio, Texas

Henri Fantin-Latour (1836 - 1904)
*Homage to Berlioz* (*Hommage à Berlioz*), 1876
lithograph, (26-3/4 in. x 20-7/8 in.)
Private Collection, San Antonio, Texas

Henri Fantin-Latour (1836 - 1904)
*Bouquet of Roses* (*Bouquet de roses*), 1879
lithograph, (17-3/4 in. x 14 in.)
Private Collection, San Antonio, Texas

Henri Fantin-Latour (1836 - 1904)
*Woman Bathing, Standing Up*
(*La Baigneuse debout*), 1896
lithograph, mounted on China paper
(11-1/4 in. x 8-1/4 in.)
Private Collection, San Antonio, Texas

Henri Fantin-Latour (1836 - 1904)
*Siegfried and the Rhine Maidens*
(*Siegfried et les jeunes filles du Rhine*), 1897
lithograph, (12-1/4 in. x 9-7/16)
Private Collection, San Antonio, Texas

Henri Fantin-Latour (1836 - 1904)
*To the Immortal Author of William Tell*
(*À l'auteur immortel de Guillame Tell*), 1902
lithograph, (15-1/4 in. x 14-7/8 in.)
Private Collection, San Antonio, Texas

Henri Fantin-Latour (1836 - 1904)
*A Mid-Summer Night's Dream*
(*Un Rêve d'une nuit d'été*), n.d.
charcoal on paper, (12 in. x 10 in.)
Private Collection, San Antonio, Texas

Henri Fantin-Latour (1836 - 1904)
*Parsifal* (*Parsifal*), n.d.
lithograph (19 in. x 13-3/8 in.)
Private Collection, San Antonio, Texas

Jean Fautrier (1888 - 1964)
*Large Vegetables* (*Grands vegetaux*), 1958
oil on paper mounted on burlap, (38 in. x 51 in.)
The Menil Collection, Houston, Texas

Jean-Louis-Andrè-Théodore Géricault (1791 - 1824)
*The French Marshal* (*Le Maréchal français*), 1822
lithograph, (16-1/2 in. x 21-3/4 in.)
Archer M. Huntington Art Gallery
The University of Texas at Austin
Purchased as a Gift of JoAnne and George Christian

Jean-Baptiste Greuze (1725 - 1805)
*Study for Le Fils Puni* (*Étude pour Le Fils Puni*), n.d.
red crayon on paper, (15 in. x 12 in.)
Private Collection, San Antonio, Texas

Henri-Joseph Harpignies (1819 - 1916)
*Trees in a Valley* (*Des arbres au vallon*) n.d.
charcoal drawing, signed lower right *Harpignies*
(7-7/16 in. x 4-15/16 in.)
Private Collection, San Antonio, Texas

Jean-Auguste-Dominique Ingres (1780 - 1867)
*Gabriel Cortois of Pressigny*
(*Gabriel Cortois de Pressigny*), 1816
etching, (14-3/4 in. x 12-1/16 in.)
Archer M. Huntington Gallery
The University of Texas at Austin
Archer M. Huntington Museum Fund

Eugène Isabey (1803 - 1886)
*Entrance to the Village of Bains*
(*Entrée au Village de Bains*), 1831
lithograph, (8-3/4 in. x 12-1/2 in.)
McNay Art Museum, San Antonio, Texas
Gift of Jane and Bert Gray
Exhibited for the first half of the exhibition.

Eugene Isabey (1803 - 1886)
*Repairing a Barge at Low Tide*
(*Radoub d'une barque àmarée basse*), 1833
lithograph, (13-1/2 x 9-3/4 in.)
McNay Art Museum, San Antonio, Texas
Gift of the Friends of the McNay
Exhibited for the second
half of the exhibition
(Fig. 112) ▼

Yves Klein (1928 - 1962)
*Cosmogony, Rain* (*Cosmogonie de la pluie*), 1961
ink on paper laid down on canvas
(25-5/8 in. x 19-3/4 in.)
The Menil Collection, Houston, Texas

Nicholas de Launay (1739 - 1792)
*The Empty Quiver,* after Pierre Baudouin
(*Le Carquois Èpuisé,* après Pierre-Antoine Baudouin), 1765
etching, progressive proof
(11-3/4 in. x 8-7/8 in.)
Archer M. Huntington Art Gallery
The University of Texas at Austin
Purchased as a gift of Marvin Vexler

▲

Nicholas de Launay (1739 - 1792)
*The Empty Quiver,* after Pierre Baudouin (*Le Carquois Èpuisé,* après Pierre-Antoine Baudouin), 1775
etching, proof before letters, (19-1/2 in. x 14-1/2 in.)
Archer M. Huntington Art Gallery
The University of Texas at Austin
Purchased as a gift of Marvin Vexler
(Fig. 113)

Henri Laurens (1885 - 1954)
*Musical Instruments*
(*Instruments de musique*), 1917
collage, (19-1/2 in. x 27-1/2 in.)
The Menil Collection, Houston, Texas

Circle of Vigée-Lebrun, (18th Century)
*Portrait of  Marie Antoinette*
(*Portrait de Marie Antoinette*), c. 1788
pastel, (100 in. x 67 in.)
The Sarah Campbell Blaffer Foundation, Houston, Texas
(Fig. 29)

Fernand Léger (1881 - 1955)
*Construction Workers*
(*Des Ouvriers en bâtiments*), n.d.
screenprint or colored lithograph
(19-1/4 in. x 24-1/2 in.)
Private Collection, San Antonio, Texas

Alphonse Legros (1837 - 1911)
*Little Marie (La Petite Marie)*, n.d.
etching, (11-5/8 in. x 8-3/8 in.)
San Antonio Museum of Art
San Antonio, Texas
Bequest of Dr. Arthur Norman

Alphonse Legros (1837 - 1911)
*The Prodigal Son (Le Fils prodigue)*, n.d.
etching, (15-1/4 in. x 10-3/4 in.)
San Antonio Museum of Art
San Antonio, Texas
Bequest of Dr. Arthur Norman

Alphonse Legros (1837 - 1911)
*Shack on the Hill*
(*Masure sur la colline*), n.d.
etching, (8 in. x 10-7/8 in.)
San Antonio Museum of Art
San Antonio, Texas
Bequest of Dr. Arthur Norman

Maximilien Luce (1858 - 1941)
*Portrait of Pissarro (Portrait de Pissarro)*, n.d.
lithograph, (9 in. x 6-3/4 in.)
Private Collection, San Antonio, Texas

Aristide Maillol (1861 - 1944)
*Standing Woman (Femme debout)*, c. 1930
pastel, (20 in. x 12 in.)
Private Collection, Austin, Texas

Edouard Manet (1832 - 1883)
*The Guitarist (Le Guitarero)*, c. 1861
etching, (11-3/4 in. x 9-5/8 in.)
McNay Art Museum, San Antonio, Texas
Gift of the Friends of the McNay
Exhibited for the first half of the exhibition.
(Fig. 114) ▶

Edouard Manet (1832 - 1883)
*The Guitarist (Le Guitarero)*, c. 1861
second impression, (11-3/4 in. x 9-5/8 in.)
McNay Art Museum, San Antonio, Texas
Bequest of Ruth S. Magurn
Exhibited for Second Half of Exhibition

Edouard Manet (1832 - 1883)
*Portrait of Berthe Morisot*
(*Portrait de Berthe Morisot*), n.d.
etching on paper, (4-5/8 in. x 3-1/8 in.)
Private Collection, San Antonio, Texas

Henri Matisse (1869 - 1954)
*Reclining Female Nude (Nue assise)*, 1918
india ink on paper, (25 in. x 18-7/8 in.)
Private Collection, San Antonio, Texas

Henri Matisse (1869 - 1954)
*Odalisque (Odalisque)* n.d.
etching signed in plate, lower right
(7-3/4 in. x 11-5/8 in.)
Private Collection, San Antonio, Texas

Charles Meryon (1821 - 1868)
*The Pump of Notre Dame (La Pompe du Notre Dame)*, 1852
etching, (6-1/2 in. x 9-5/8 in.)
Private Collection, San Antonio, Texas

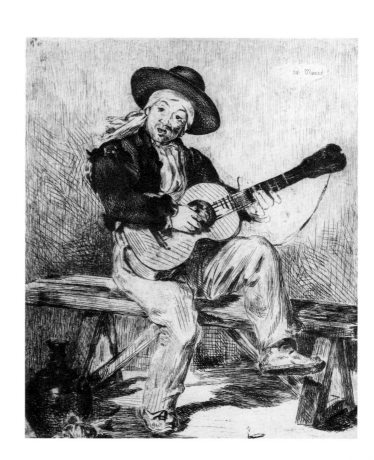

Circle of Pierre Milan and René Boyvin
(c.1525 - 1580)
*The Nymph of Fontainebleau*, after Rosso Fiorentino
(*La Nymphe de Fontainebleau*, après Rosso Fiorentino)
c. 1554
engraving, (12-1/4 in. x 19-3/4 in.)
Archer M. Huntington Gallery
The University of Texas at Austin
Purchased through the generosity of the
Still Water Foundation
(Fig. 115)

Jean-François Millet (1814 - 1875)
*The Gleaners (Les Glaneurs)*, 1855-56
etching on wove paper, (7-1/4 in. x 10 in.)
Private Collection, San Antonio, Texas

Jean François Millet (1814 - 1875)
*The Sower (Le Sémeur)*, n.d.
lithograph, (8-1/4 in. x 6-1/8 in.)
Private Collection, San Antonio, Texas

Berthe Morisot (1841 - 1895)
*Skaters (Les Patineurs)*, c. 1874
pastel on paper, (17-1/4 in. x 23-1/4 in.)
Private Collection, San Antonio, Texas
(Fig. 11)

Robert Nanteuil (1623 - 1678)
*Victor Bouthillier, Archbishop of Tours*
(*Victor Bouthillier, Archevêque de Tours*), 1662
engraving, (14-15/16 in. x 18-7/8 in.)
Archer M. Huntington Gallery
The University of Texas at Austin
Purchased through the generosity of the
Still Water Foundation

Camille Pissarro (1830 - 1903)
*Haymakers (Les Fenaiseurs)*, n.d.
etching, signed lower right *C. Pissarro* in pencil
(8 in. x 5-15/16 in.)
Private Collection, San Antonio, Texas

Pierre Puvis de Chavannes (1824 - 1898)
*Abundance* (*Abondance*), n.d.
lithograph on Japan paper, (12-3/8 in. x 6 in.)
Private Collection, San Antonio, Texas

Odilon Redon (1840 - 1916)
*Portrait of Pierre Bonnard*
(*Portrait de Pierre Bonnard*), n.d.
lithograph, (7-1/2 in. x 6 in.)
Private Collection, San Antonio, Texas

Odilon Redon (1840 - 1916)
*Still Life-Vase and Flowers*
(*Nature Morte-Vase et Fleurs*), n.d.
pastel, signed lower right *Odilon Redon*
(15 in. x 12 in.)
Private Collection, San Antonio, Texas
(Fig. 12)

Nicolas-François Regnault (1746 - 1810)
*The Stolen Kiss*, after Fragonard
(*Le Baiser à la derobée*, après Fragonard), 1788
stipple etching and engraving
(16-1/2 in. x 19-1/8 in.)
Private Collection, San Antonio, Texas

Pierre Auguste Renoir (1841 - 1919)
*Portrait of Richard Wagner*
(*Portrait de Richard Wagner*), n.d.
aquatint, (16-3/4 in. x 12-3/4 in.)
Private Collection, San Antonio, Texas

Auguste Rodin (1840 - 1917)
*Nude* (*Nue*), c. 1910
water color, (8 in. x 12 in.)
Private Collection, Austin, Texas

Georges-Dominique Rouault (1871 - 1958)
*Crucifixion* (*Crucifixion*), 1936
lithograph signed lower right
*Georges-Dominique Rouault*
(25-1/2 in. x 19-1/2 in.)
Private Collection, San Antonio, Texas

Jean-Claude-Richard de Saint-Non (1727 - 1791)
*Cupid and Psyche*, after François Boucher
(*Cupidon et Psyché*, après François Boucher), 1766
etching, (11-5/8 in. x 14-1/2 in.)
Archer M. Huntington Art Gallery
The University of Texas at Austin
Purchased as a gift of Marvin Vexler

Paul Signac (1863 - 1935)
*The Wreckers* (*Les Démolisseurs*), 1896
lithograph, (19-1/4 in. x 12-1/8 in.)
Private Collection, San Antonio, Texas

Paul Signac (1863 - 1935)
*Harbor at St. Tropez* (*Le Port à St. Tropez*), n.d.
water color on paper, (6-3/4 in. x 9-7/16 in.)
Private Collection, San Antonio, Texas

Israel Silvestre, the Younger (1621 - 1691)
*The Pleasures of the Enchanted Isle*
(*Les Plasiers de île enchantée* ), 1666
etching, (11-1/8 in. x 16-3/4 in.)
Archer M. Huntington Gallery
The University of Texas at Austin
Archer M. Huntington Museum Fund

James Jacques Tissot (1836 - 1902)
*The Prodigal Son* (*Le Fils prodigue*), 1881
etching, (11 in. x 14-1/2 in.)
Private Collection, San Antonio, Texas

Henri de Toulouse-Lautrec (1864 - 1901)
*Divan Japonais* (*Divan Japonais*), 1893
lithograph, (30-3/8 in. x 24-1/2 in.)
Private Collection, San Antonio, Texas

Henri de Toulouse-Lautrec (1864 - 1901)
*Le Petit Trottin* (*Le Petit Trottin*), 1893
lithograph, printed in green with stencil coloring,
(11-1/4 in. x 7-1/2 in.)
Private Collection, San Antonio, Texas

Henri de Toulouse-Lautrec (1864 - 1901)
*Irish American Bar, Rue Royale*
(*Un Bar Irlandais-Américain, Rue Royale*), 1896
lithograph printed in colors, (16-1/2 in. x 23-1/2 in.)
Private Collection, San Antonio, Texas

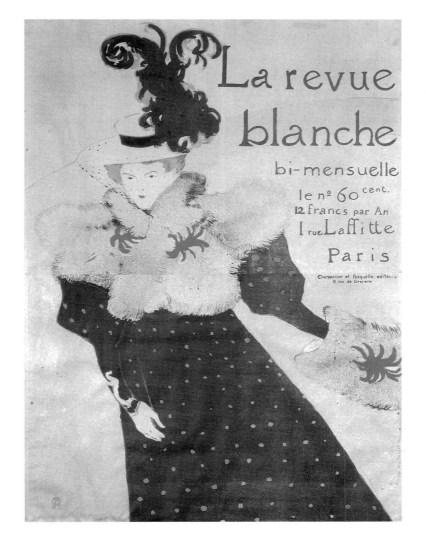

Henri de Toulouse-Lautrec
(1864 - 1901)
*La Revue blanche*
(*La Revue blanche*), n.d.
lithograph, (50 in. x 36 in.)
Private Collection
San Antonio, Texas
(Fig. 116) ▶

Félix Vallotton, (1865 - 1925)
*The Trench* (*La Tranchée*), n.d.
woodcut, (7 in. x 8-3/4 in.)
Private Collection
San Antonio, Texas

Carle van Loo (1705 - 1765)
*A Man Seen from the Front*, Frontispiece of *Six Academic Figures* (*Un Homme vue devant*, Frontispiece de *Seis Figures Academiques*), 1743
etching, (16-5/8 in. x 12-1/8 in.)
Archer M. Huntington Gallery
The University of Texas at Austin
Archer M. Huntington Museum Fund

Carle van Loo (1705 - 1765)
*A Man Turned Toward the Left*, from *Six Academic Figures* (*Un Homme se Tourne à Gauche*, de *Seis Figures Academiques*), c. 1743
etching, (16-9/16 in. x 12-1/8 in.)
Archer M. Huntington Gallery
The University of Texas at Austin
Archer M. Huntington Museum Fund

Jacques Villon (1875 - 1963)
*Self-portrait* (*Autoportrait*), n.d.
drypoint, (8-1/2 in. x 7 in.)
Private Collection, San Antonio, Texas

Dominique Vivant-Denon (1747 - 1825)
*Self-portrait at many Stages of his Life*
(*Autoportrait*), 1818
lithograph, (17-3/8 in. x 20-5/8 in.)
Archer M. Huntington Art Gallery
The University of Texas at Austin
Archer M. Huntington Museum Fund